IMAGES
of America

JUNIATA COLLEGE
UNCOMMON VISIONS OF
JUNIATA'S PAST

IMAGES
of America

JUNIATA COLLEGE
UNCOMMON VISIONS OF
JUNIATA'S PAST

Nancy Siegel

ARCADIA

Published by Arcadia Publishing,
an imprint of Tempus Publishing, Inc.
2 Cumberland Street
Charleston, SC 29401

Printed in Great Britain.

Library of Congress Catalog Card Number applied for.

For all general information contact Arcadia Publishing at:
Telephone 843-853-2070
Fax 843-853-0044
E-Mail arcadia@charleston.net

For customer service and orders:
Toll-Free 1-888-313-BOOK

Visit us on the internet at http://www.arcadiaimages.com

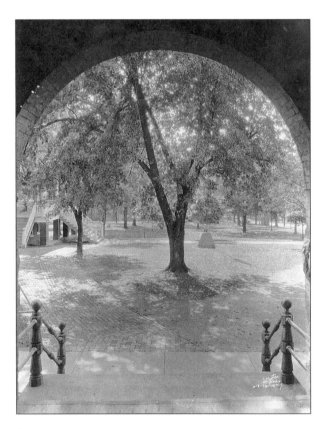

This view of Founders Hall was photographed through the archway of Students' Hall (no longer in existence) on the Juniata College campus.

CONTENTS

Acknowledgments 6

Foreword 7

Introduction 9

1. Founding Figures and Families 11

2. Faculty and the Curriculum 19

3. Through These Hallowed Halls 35

4. School Spirit and Traditions 49

5. Team Spirit 67

6. Filling Our Days with Friendship 85

7. Those Who Have Come before Us 103

8. Out and about in Huntingdon 119

Dedication 128

ACKNOWLEDGMENTS

This visual history of Juniata College would not have come to fruition without the assistance of numerous individuals. I am grateful for the support of the administration at Juniata College, in particular, to Dr. Thomas R. Kepple Jr., the 11th President of Juniata College; Provost and Vice President for Student Development Dr. James Lakso; Vice President for Advancement and Marketing John Hille; and Director of External Relations and Marketing David Gildea. I would also like to thank Rosann Brown, publications coordinator, and Dr. Donald Durnbaugh, college archivist, who has made available to me numerous resources. Harold Brumbaugh deserves special gratitude for his willingness to answer my many questions.

All of the images in this publication come from the archive collection at Juniata College. I am grateful to the alumni, friends, and families of Juniata who generously have donated their personal keepsakes so that a visual history of the college might exist. I am appreciative of the cataloging work of Brian Hack, who first began the classification and organization of this extensive collection. I would like to thank Assistant Professor of History Belle Tuten, under whose direction members of the History Club have begun updating the classification for our database. To these students I owe a special thanks. Additionally, I would like to extend my gratitude to the art department at Juniata College for their encouragement and support: Professors Karen Rosell, Alexander McBride, and Jack Troy, with special thanks to Phillip Earenfight, who has given not only his support, but his time, suggestions, and his unerring eye for design and layout.

Every effort has been made to describe with historical accuracy the images herein. Any faults, flaws, or errors are the sole responsibility of the author.

FOREWORD

From the beginning, Juniata has been a distinctive college. It began, as all important things do, with vision and commitment. The founders, Henry, John, and Andrew Brumbaugh, along with James Quinter and Jacob Zuck, had an uncommon vision for a college founded, not on the gender restricted models of Oxford, Cambridge, Harvard, and Princeton, but on the values of the Church of the Brethren: community, peace, and service. These values are perhaps even more important today than in 1876.

Each of these individuals, and the many generations of loyal members of the Juniata family, have given much of their lives and their resources to strengthen Juniata. One outstanding example is Harold Bennett Brumbaugh, to whom this book is dedicated. Because of the uncommon vision and commitment of H.B. and many others, Juniata holds a place of distinction among the many fine collegiate institutions in this country. It is with great excitement that Juniata looks forward to the many challenges, responsibilities, and commitments we face in the years ahead. This book recalls Juniata's past and encourages us to look boldly and with eager anticipation toward Juniata's future.

From Juniata's simple origins in one room, located over a printing shop, to its prominence as a leading liberal arts college, it is my wish that the words and images in this publication serve as reminders of a not so distant past. As you turn the pages of Juniata's history, I invite you to share this uncommon vision and join with the Juniata family in renewing an uncommon commitment.

Thomas R. Kepple Jr

Thomas R. Kepple Jr.
President

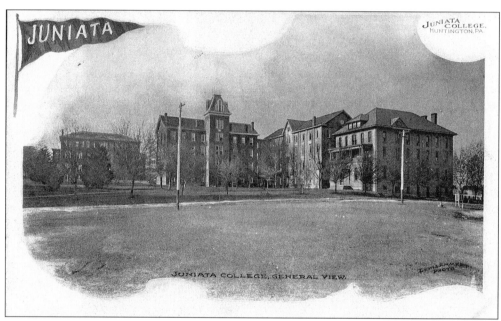

"A right little, tight little college." (I. Harvey Brumbaugh.)

INTRODUCTION

Uncommon Visions of Juniata's Past documents the visual history of Juniata College from its founding in 1876 through the 1920s. The images contained in this book focus on the history, daily life, and environs of Juniata's campus and Huntingdon, Pennsylvania. These picture postcards and posed snapshots reveal a fascinating early history of the college in an era before color photography. In creating a social and cultural context to better appreciate the past, it becomes apparent that although much has changed over the years, much more remains the same. The following pages explore the unique and rich history of the college with the intention of rekindling old memories while creating new ones. All of the images chosen for this book represent but a small portion of the archival collection of the Juniata College Museum of Art. Most have never been published, and many are complemented with captions that are excerpts from historical documents. This selection of photographs is meant to serve as an introduction to the college's holdings and to promote further interest in the cultural heritage of Juniata College.

This visual account joins a list of existing titles devoted to the history of the college. In 1901, David Emmert wrote *Reminiscences of Juniata College*, a colorful history of the school's first 25 years. Charles Calvert Ellis followed in 1947 with the now classic text, *Juniata College, the History of Seventy Years 1876–1946*, to celebrate the 70th anniversary of the college. In 1977, Earl C. Kaylor Jr., a Charles A. Dana Supported Professor of History and Religion, (Emeritus), wrote *Truth Sets Free, A Centennial History of Juniata College, 1876–1976*. So acclaimed, a revised edition is forthcoming. These works have been instrumental in apprising and informing me of the unique and proud history of this institution. I am indebted to each of these gentlemen for the work that precedes my own and would encourage the reader to consult these sources for extensive historical information.

Of course, this book would not have been possible without the collecting sensibility of Harold Bennett Brumbaugh. H.B., as he is known in the community, has contributed to this project invaluable amounts of his time and knowledge about the college, its history, respected founders, and folklore—past and present. H.B. is a member of the class of 1933 and has served as assistant to the president, alumni secretary, and vice president for college relations. Until its recent transfer to the Juniata College Museum of Art, the collection of archival photographs, collectibles, and memorabilia that documents Juniata College's history has been under the care, tutelage, and stewardship of H.B. for a Juniata eternity. This book is dedicated to Harold Bennett Brumbaugh on behalf of Juniata College, to honor and recognize his many years of devoted service and personal sacrifice to the school that he so dearly loves.

—Nancy Siegel, Curator
Juniata College Museum of Art

One

FOUNDING FIGURES
AND FAMILIES

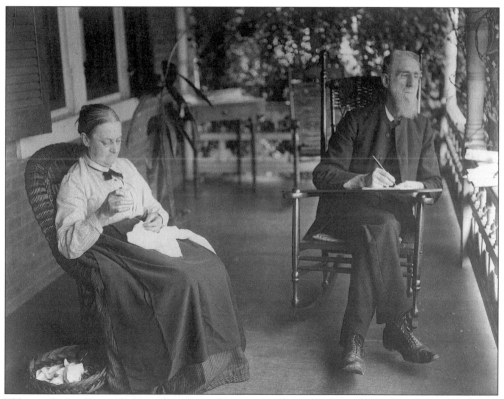

Elder and Mrs. Henry B. Brumbaugh can be seen on the verandah of their home on 17th Street in Huntingdon. Elder H.B. not only helped to found the college with his brother John and cousin A.B. Brumbaugh, but he served as its second president from 1888 to 1893.

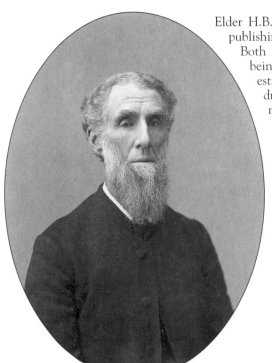

Elder H.B. Brumbaugh and his brother John began publishing the *Pilgrim*, a weekly religious paper. Both men advocated higher education. Upon being convinced by cousin A.B. Brumbaugh to establish a school in Huntingdon, H.B. dreamed one night of a large student body marching down Main Street.

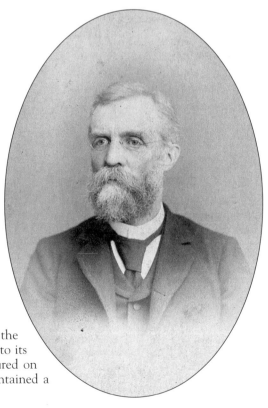

Dr. Andrew Boelus Brumbaugh, one of the founding figures of the school, was devoted to its educational and financial success. He lectured on hygiene each Thursday afternoon and maintained a private medical practice in Huntingdon.

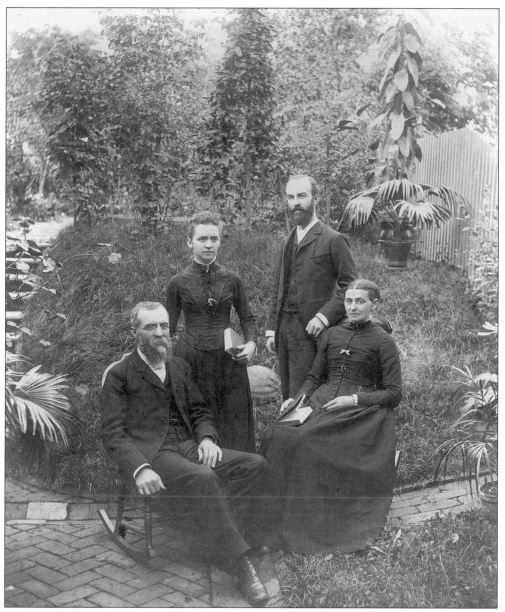

Dr. A.B. Brumbaugh poses with his wife, Maria (seated), and his children, Cora and Gaius. Dr. A.B. once said, "[t]he time will come when the influence of this school movement will be felt from the Atlantic to the Pacific, and from the Lakes to the Gulf." (Memorial service for Professor Jacob Zuck, June 12, 1879.)

James Quinter became the first president of Juniata College from 1879 to 1888. He assumed the position shortly after the death of the school's first teacher, Jacob Zuck. "An Uncommon Vision, An Uncommon Commitment," were the words spoken by James Quinter to describe the goal and direction of this institution from its founding in 1876. He died at the age of 72 while preaching at an annual meeting.

Elder James Quinter is shown here with his wife and daughters, Grace and Mary, c. 1884.

Elder John B. Brumbaugh was determined that an educational enterprise begin in one of the rooms of the *Pilgrim*'s printing shop. J.B. later taught in the Bible department and was an active solicitor for the school.

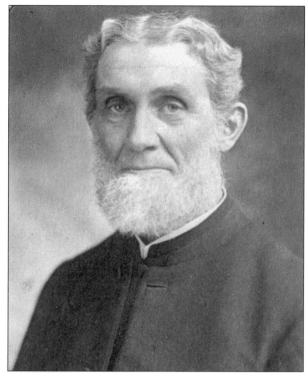

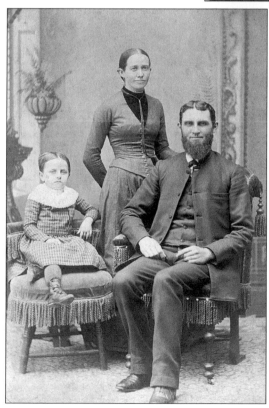

Elder J.B. Brumbaugh poses here with his wife, Ella, and their daughter Ruth, *c*. 1888.

"Let us consider briefly some of the salient objectives of this college, for it is essential that any institution dedicated to the higher learning should be wisely led . . ." (Inaugural address of Martin Grove Brumbaugh, January 29, 1925.) Martin Grove Brumbaugh was Juniata's third and fifth president from 1893 to 1910 and 1924 to 1930.

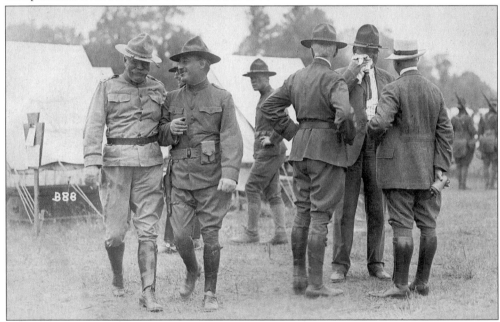

Martin Grove Brumbaugh was a graduate of the college's English department. He was appointed county superintendent of schools for Huntingdon County at the age of 22 and, in 1900, he was appointed by President McKinley as commissioner of education to Puerto Rico. M.G. Brumbaugh was also governor of Pennsylvania from 1915 to 1919. He is photographed here (second from right) with members of the 53rd Infantry.

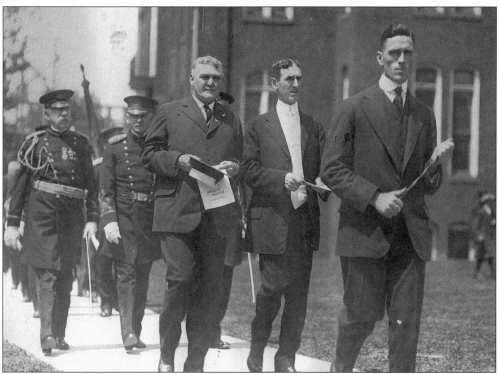

M.G. returned to Juniata College for the 1916 commencement exercises. He is joined by President Isaac Harvey Brumbaugh (to the right); leading the way is Meyers B. Horner, a member of the faculty.

Isaac Harvey Brumbaugh taught Greek and Latin before becoming the school's fourth president from 1911 to 1924, in addition to serving as acting president from 1899 to 1911 during M.G. Brumbaugh's lengthy presidential absences. While in office, I. Harvey was responsible for adopting the college's motto: Veritas Liberat (the Truth Sets Free), in 1902.

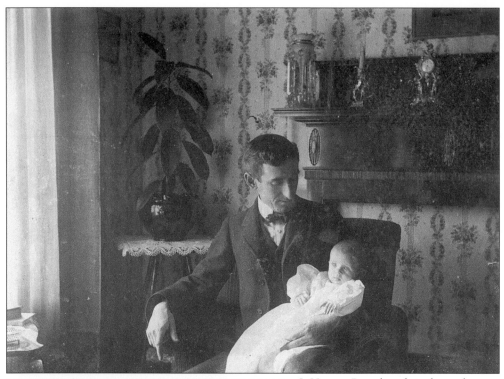

I. Harvey Brumbaugh is shown here holding his eldest child.

A youthful Charles Calvert Ellis graduated from the Normal English Course before he turned 16 years of age. He assumed the title of Juniata's sixth president in 1930.

Two

FACULTY AND THE CURRICULUM

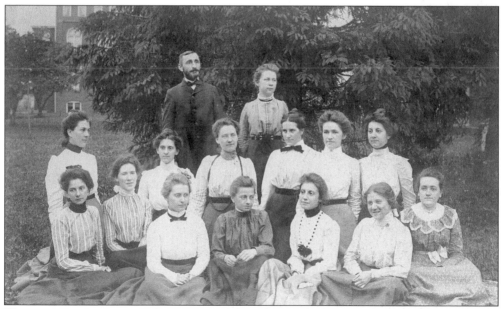

"Do you want to give special attention to the cultivation of your voice? The teachers in the musical department are ready to accommodate you." (*Juniata Echo*, November 1890.) The ladies' chorus can be seen here with Professor A.H. Haines, *c.* 1902.

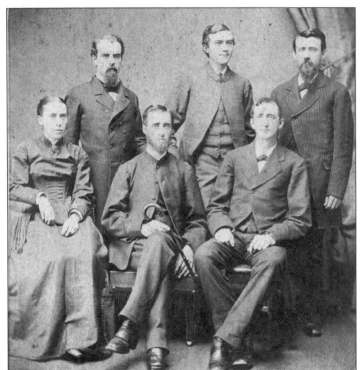

In this picture of the Normal School faculty in 1878, the school's first instructor, Jacob Zuck, is seated with a cane. Surrounding him are Phoebe Weakley and John C. Ewing. Behind them stand Jacob H. Brumbaugh, David Emmert, and A.S.M. Anderson. Zuck taught the general subject of "Mental and Moral Science." He died on May 10, 1879.

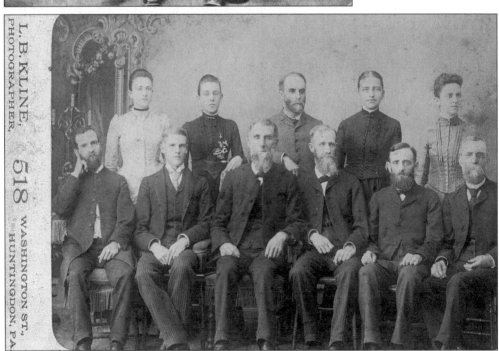

Seen here, from left to right, is the 1890 faculty of Juniata College, as follows: (front row) W.J. Swigart, Arthur Walker, H.B. Brumbaugh, William Beery, Joseph Saylor, and A.B. Brumbaugh; (back row) Ida Pect, Sarah S. Kirk, J.H. Brumbaugh, Elizabeth Howe Brubaker, and Cora A. Brumbaugh.

William Beery, while a student at the Normal School, was one of three students forced to take refuge in the woods during the smallpox epidemic in Huntingdon in 1878. He later joined the teaching staff as an instructor in music from 1878 to 1885 and 1888 to 1908. Beery also served as a trustee from 1878 to 1908.

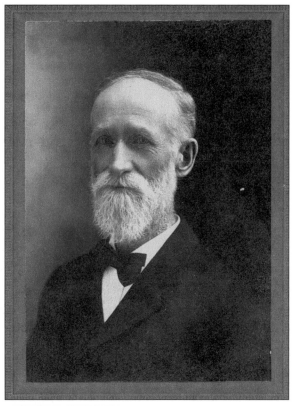

Miss Sarah Kirk, seen here in this 1889 photograph, served the college as an English teacher.

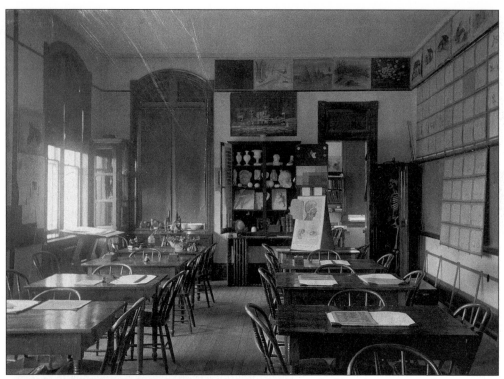

Professor Emmert taught art, botany, and biology in this classroom.

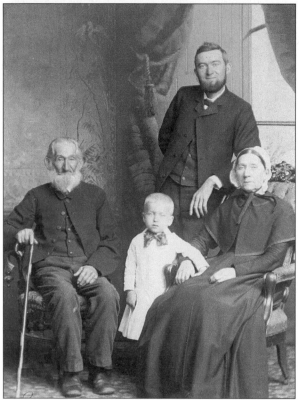

David Emmert, shown here with his parents and one of his three sons, was a professor of drawing, painting, botany, and biology. He also wrote a college history (*Reminiscences of Juniata College*, 1901), in addition to being an artist and a humanitarian.

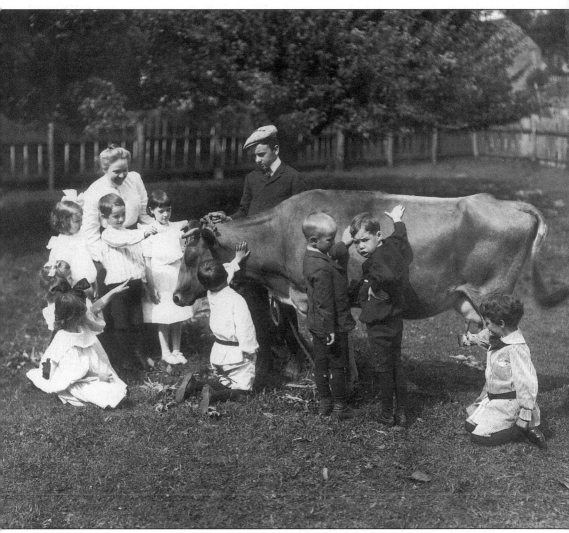

In 1883, David Emmert devoted himself to the foundation and administration of an orphanage in Huntingdon. Emmert served as superintendent of the Home for Orphan and Friendless Children for ten years and appointed Miss Carrie Miller as its first matron. Over the course of his life, Emmert successfully placed more than 800 children in permanent homes. The orphans are shown here fawning over a cow.

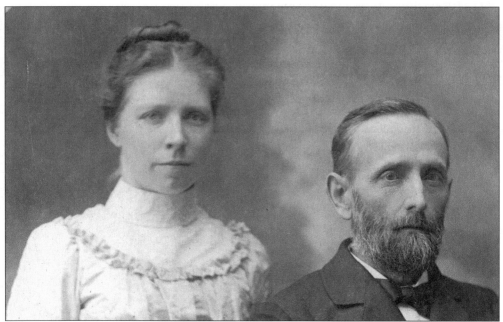

Professor and Mrs. Joseph E. Saylor can be seen in this image. Professor Saylor taught mathematics, astronomy, and bookkeeping. "Mathematics develops in the individual: patience, perseverance, precision, accuracy, neatness, order, determination, quickness of apprehension, foresight, judgment, and restrains the tendency to speculative belief." (Joseph Saylor, *Juniata Echo*, February 1899.)

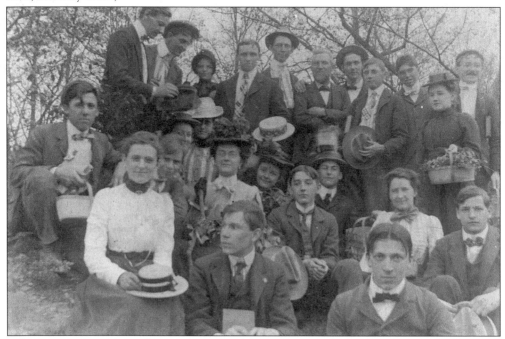

"The botany classes have frequently reported fifty species gathered on a single afternoon and that without a serious effort to fill the herbarium at the expense of sociability." (D. Emmert, 1901.) Professor Emmert led this botany trip in 1902.

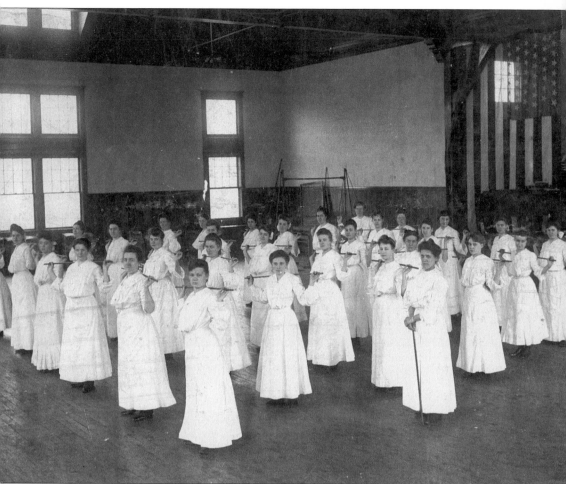

"The exercises in the gymnasium are attended very regularly by the gentlemen; the ladies have not been doing so well, but we expect them to become quite enthusiastic when they are allowed to take hold of the apparatus. As yet neither class has handled anything like dumb-bells." (*Juniata Echo*, December 1896.) The ladies' gym class is shown here exercising in the old gym.

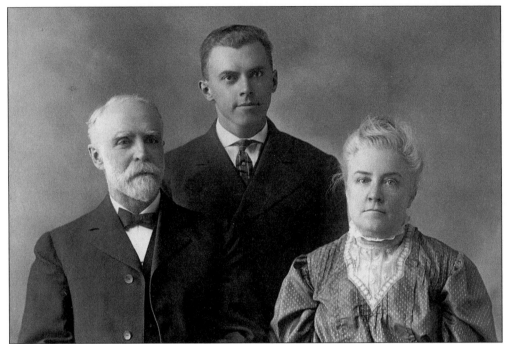

Jacob H. Brumbaugh poses with his wife and their son Norman, who later joined the faculty. Jacob H. taught education courses from 1877 to 1923 and became principal of the college from 1878 to 1881, after Jacob Zuck's untimely death, and again from 1883 to 1893. Under J.H.'s administration, the college expanded in size and class offerings.

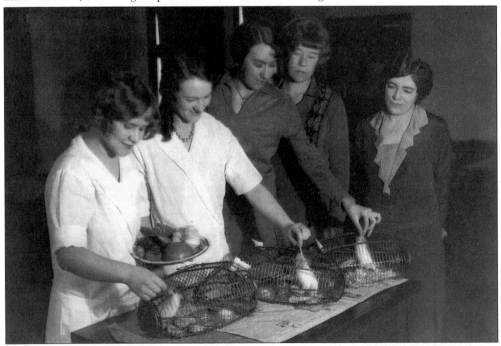

"The privilege and I may say the duty of improving one's talent is incumbent upon women and men." (Elizabeth Rosenberger, "Women's Higher Education," *Juniata Echo* 1900.)

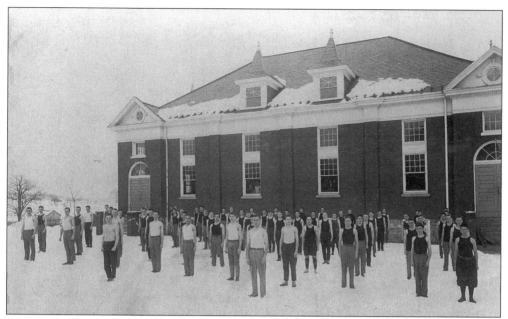

"Unusual advantages are afforded to students who come to Huntingdon to school." (*Juniata Echo*, February 1891.) The men's gym class is visible in the snow during the early 1920s.

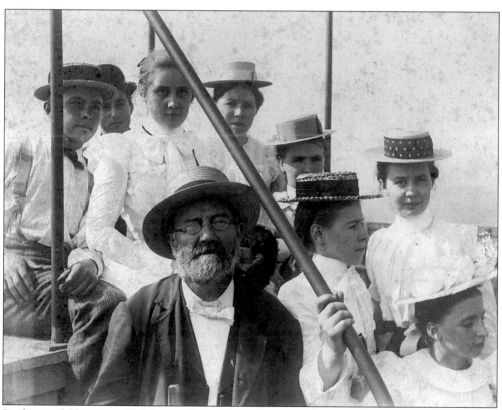

Professor of Chemistry Dr. Norman J. Brumbaugh poses with some of his students.

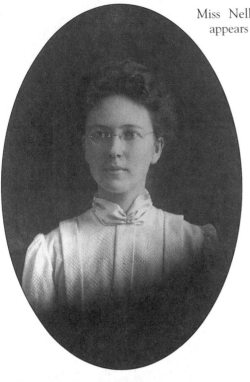

Miss Nellie McVey, teacher of instrumental music, appears in this *c.* 1902 Christmas photograph.

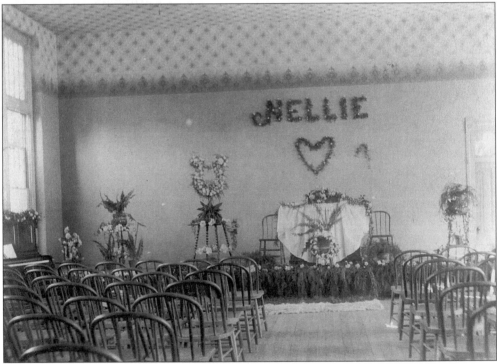

Memorial services were held for Nellie McVey in the college auditorium after her death on October 23, 1905.

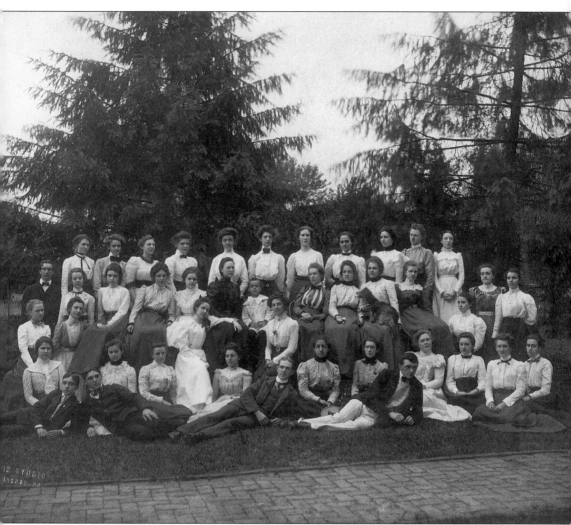

"Her music recitals are always events of much interest and pleasure to the students and appreciative friends in the town." (D. Emmert, 1901.) Miss McVey's 1899–1900 music class appears in this image.

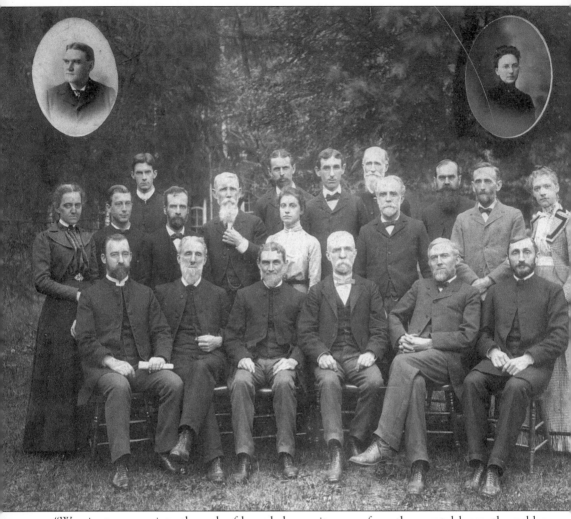

"We aim to weave into the web of knowledge, as it comes from the mental loom, the golden threads of that higher knowledge which makes the finished fabric acceptable to the Great teacher." (*Juniata Echo*, February 1891.) This image shows Juniata College's 1900 faculty.

Dr. F.H. Green instructed in literature and grammar for four years during the 1880s. Upon his return to his alma mater, West Chester State Normal School, he was succeeded by Miss Sarah Kirk.

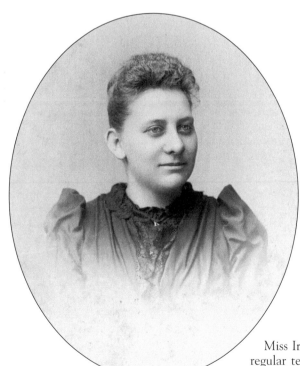

Miss Irene Kurtz replaced Ida Pecht, the first regular teacher of instrumental music, in 1892. This photograph was taken in 1896.

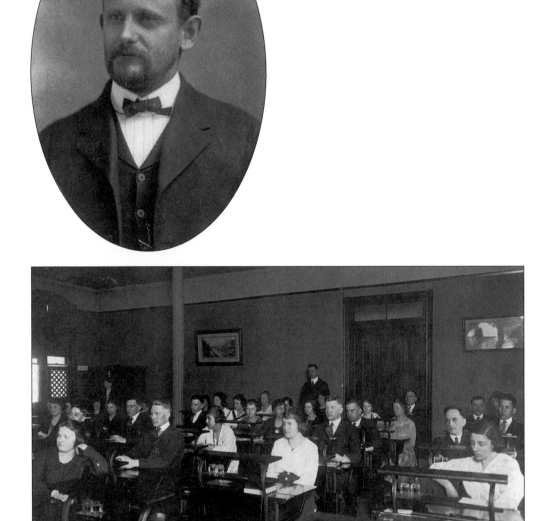

Professor Frank Holsopple taught English at Juniata College from 1891 to 1892 and again from 1901 to 1914.

"Thorough training can here be had in all branches and all departments of learning that are necessary to equip young people for the responsible duties in life, or desirable for their pleasure or happiness." (*Juniata Echo*, February 1891.) These students attended a business class during the 1919 to 1920 school year.

"The laboratory for General Chemistry has been recently improved by a new hood and a drain pipe and exhaust fan. A chemical reference library has been established, proving of great convenience to the students." (*Juniata Echo*, March 1914.)

William J. Swigart was associated with the school from its early beginnings. He taught Evidences of Christianity and Elocution from 1879 to 1919. In addition, he served as a trustee to the school for 60 years.

33

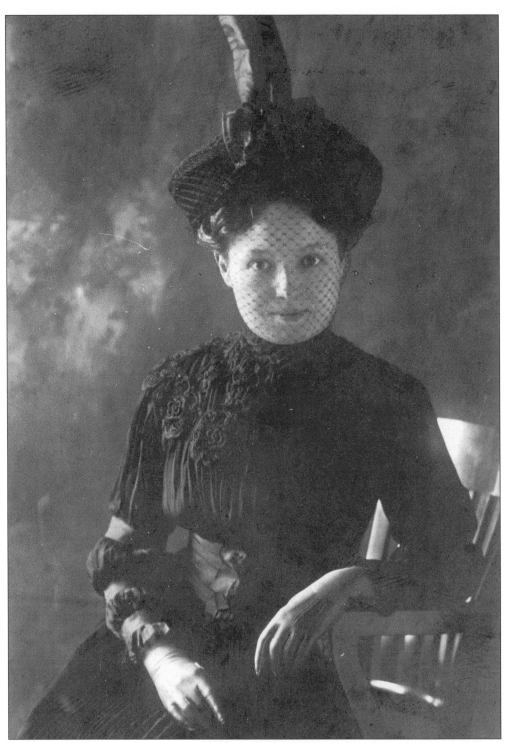

Miss Bertha Barley taught French from 1925 to 1934. She was nicknamed "the covered wagon" because, despite the gentle urgings of her students, she was never seen in public without a hat upon her head.

Three

THROUGH THESE HALLOWED HALLS

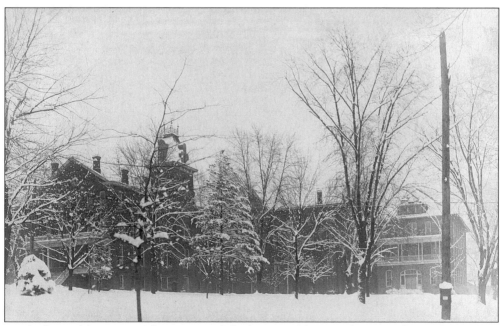

"In the beautiful Juniata Valley is situated the historic old town of Huntingdon, well suited for a school town, offering safer and better conditions of living than are possible in larger towns and cities. Huntingdon has the modern conveniences of telegraph, telephone, electric lights, and water works; and is very accessible from all parts of the country because [it is] situated on the mainline of the Pennsylvania Railroad. The healthfulness and beauty of the surroundings contribute much to the pleasure of student life at Juniata." (I. Harvey Brumbaugh, *Juniata Echo*, June 1900.)

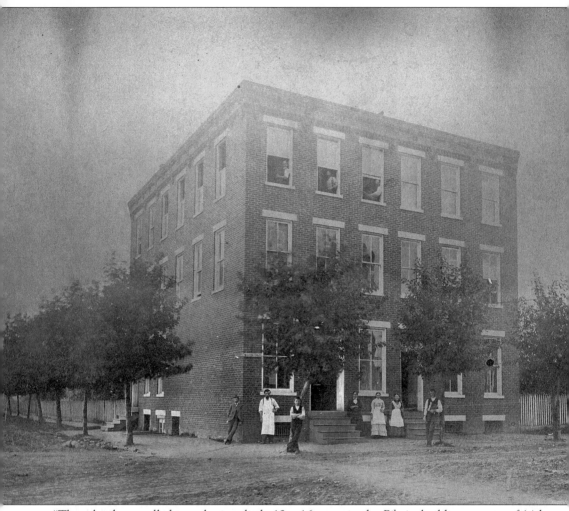

"The school was called to order in a little 12 x 16 room in the *Pilgrim* building, corner of 14th and Washington streets, then the property of Messrs. H.B. and J.B. Brumbaugh, at whose invitation, in conjunction with that of Dr. A.B. Brumbaugh, who secured the first pupils and donated some equipment, I came here to start a school." (Jacob Zuck, 1879 Anniversary Address.) While H.B., J.B., and cousin A.B. Brumbaugh founded this institution of higher learning, the *Pilgrim* building was the location of the first classrooms and school chapel. Originally called the Brethren Normal School, and later the Normal College, the school ultimately adopted the name Juniata College in 1894, in reference to the local river. Jacob Zuck taught the first class on April 17, 1876, to three students. The chapel was positioned on the first floor, followed by the school on the second, with the offices for the *Pilgrim* on the third.

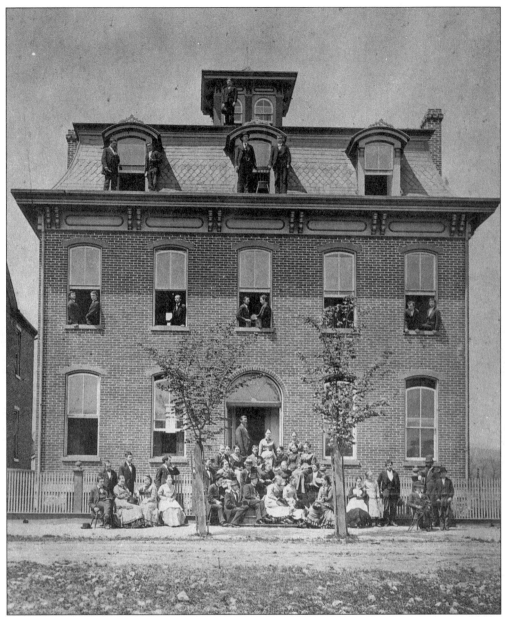

Burchinell House, now destroyed, was located at 1224 Washington Street. Very quickly, the accommodations in the *Pilgrim* building were no longer adequate and Burchinell housed the school from February 1877 until April 1879. A group of male and female students, joined by Professors Zuck and Emmert, formed a boarding club at Burchinell. "The Orphans," as they were called, took their meals together, which usually consisted of scorched potato soup and bread.

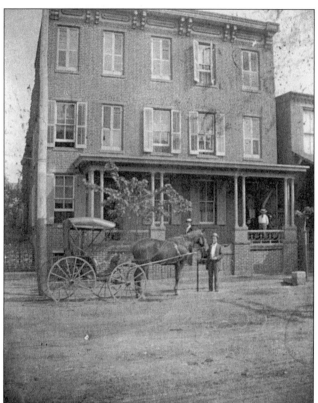

During the early years of the college, students and faculty boarded in private homes. Professors A.S.M. Anderson and Jacob Brumbaugh shared a third-floor room at Dr. A.B. Brumbaugh's downtown house and office.

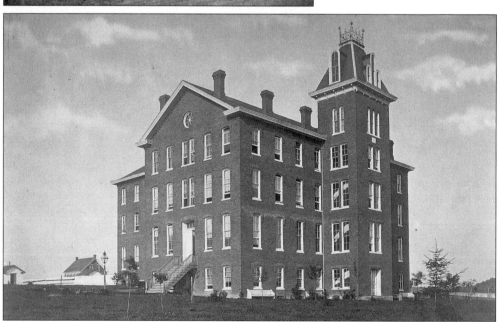

"When school opened in the new quarters, we were practically in the middle of a plowed field. Fences were not yet built nor walks laid out, and not a tree had been set. The students took a deep interest in improving the surroundings. They planted trees at their own expense and during the weeks of the term carried water to ensure their growth." (D. Emmert, 1901.)

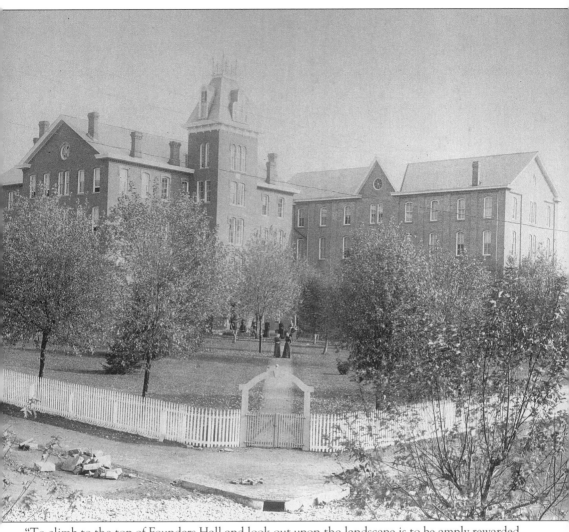

"To climb to the top of Founders Hall and look out upon the landscape is to be amply rewarded for the toil." (D. Emmert, 1901.) Founders Hall is situated on a 3-acre lot donated by the townspeople of Huntingdon. It was occupied in April of 1879, and known simply as "the Building." It was named Founders Hall in 1897. The dining room, kitchen, and pantry were located in the basement, with the principal's office, the chapel, two classrooms, and sleeping quarters for women on the first floor. The library was located in room 56 of this floor. On the second floor were additional classrooms, teachers' quarters, women's rooms, and study rooms for day students. The top floor housed additional men's dormitories.

These are the published offerings at Juniata College from the turn of the 20th century.

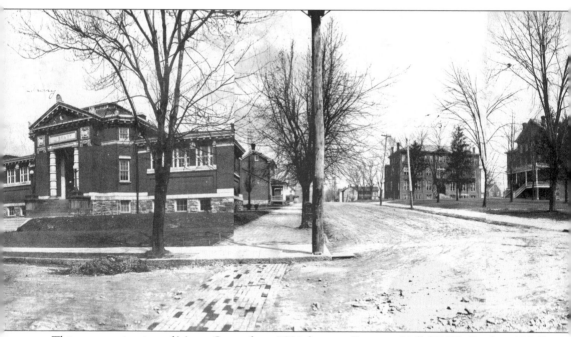

This panoramic view of Moore Street from 1921 features Carnegie Hall (1907), Students' Hall (1895), Founders Hall (1879), Ladies' Hall (1890), Oneida Hall (1898), and the Stone Church of the Brethren (1910).

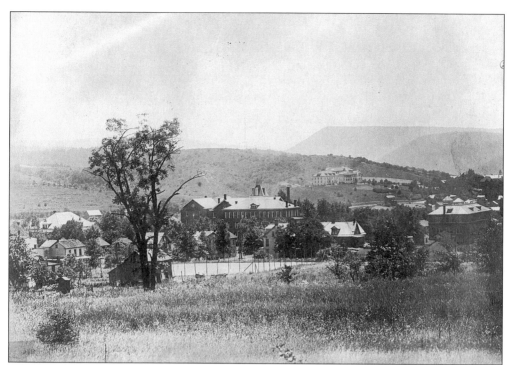

This view of campus shows the hospital in the distance.

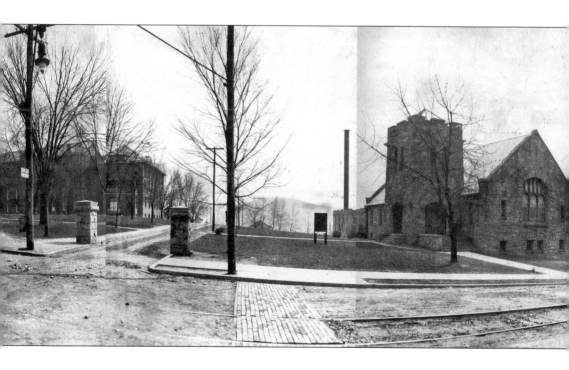

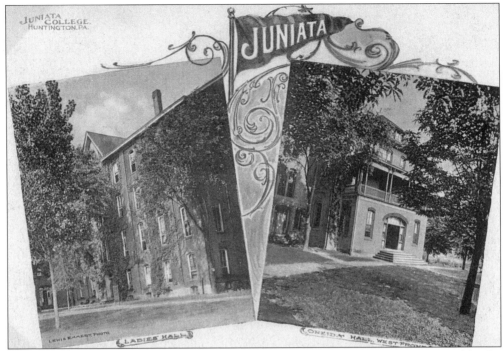

"The College Buildings are all of brick, substantially constructed, conveniently arranged for the comfort, convenience, and use of the occupants. The new building, recently constructed, is separated from the original building by a transept through which the corridors extend from one to the other. It is the *ladies' building*, and is provided with every convenience to fully establish the idea and claim of a *home* as well as a *school*." (*Juniata Echo*, November 1890.) This postcard depicts Ladies' Hall and Oneida Hall.

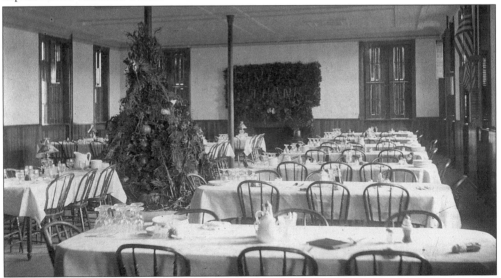

Oneida Hall was completed in 1898 with the entire first floor devoted to a new dining hall. "The methods of cooking were revolutionized." (D. Emmert, 1901.) The holiday message "Give Thanks" can be found within the wreath on the rear wall. Ladies roomed on the two upper floors. Oneida was attached to the south end of Ladies' Hall.

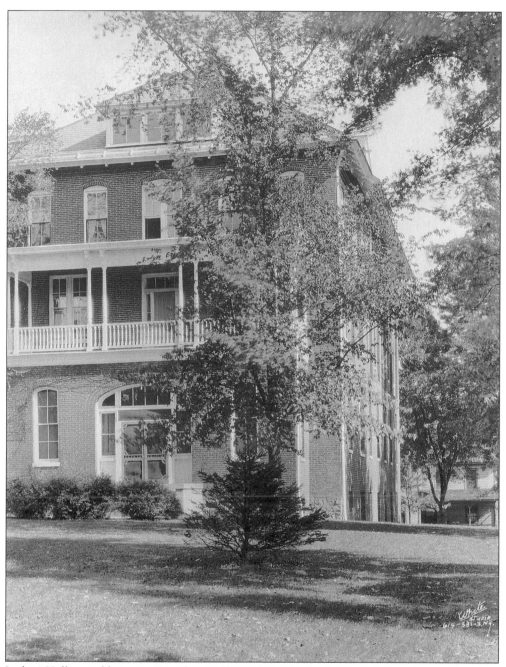

Ladies' Hall, an addition to Founders Hall in 1890, added a business department on its upper floor, while accommodating additional dormitory space for women. A diagonal walkway out of the building was to be used by ladies only. "Will the gentlemen please remember that they should keep off the diagonal walk which is reserved for the ladies- by order of the girls of the senior class." (*Juniata Echo* 1900.)

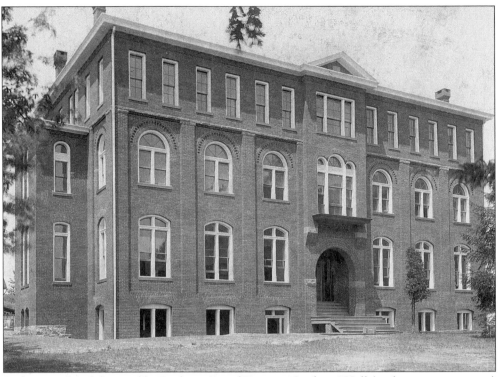

Built in 1895 and designed by Professor David Emmert, Students' Hall (no longer in existence) was located at 18th and Moore Streets. It contained science laboratories and the first gymnasium in the basement. The college library was on the west side of the main floor, with two classrooms on the east. The third floor added four additional classrooms and the top level housed 25 men.

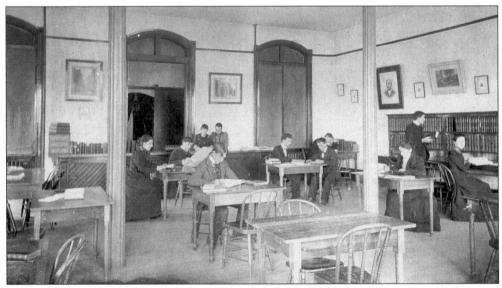

The library in Students' Hall was originally staffed by students and faculty until a librarian could be afforded in 1904. This expansion in space was quite an achievement from the early days when the "library" was located in a corner of Professor Zuck's room.

Current guests lodging in Baker House should be aware that it was originally the site of the T.T. Myers (Dean of the School of Theology) House, built by M.G. Brumbaugh, which housed the music department for many years.

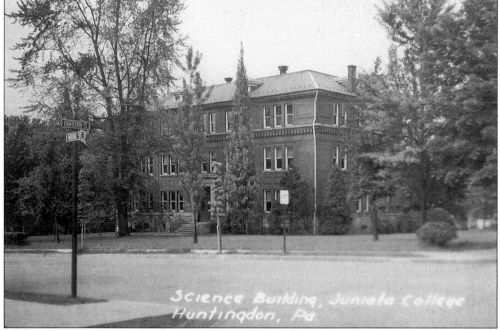

Science Hall (expanded and renamed Good Hall in 1967) was built in 1916; like Carnegie Hall, it was designed by architect Edward Tilton. Physics dominated the ground floor with biology and geology laboratories on the floor above. The third story was occupied by the departments of chemistry and home-economics.

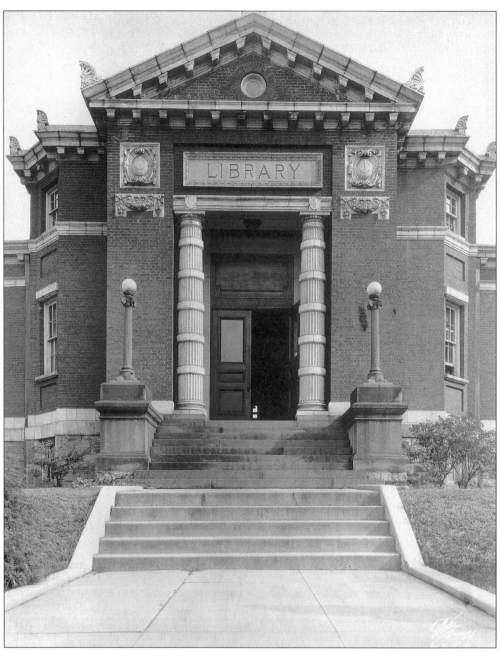

"Standing on a site made possible by the generosity of Huntingdon citizens, and endowed to the extent of $20,000 by friends of the college, the magnificent new library which has been built by the munificence of the famous American Steel King and founder of libraries, Andrew Carnegie, and now freely thrown open to the public and dedicated, is one of the most beautiful edifices of which Huntingdon or the entire Juniata Valley can boast." (*Juniata Echo*, May 1907.) Carnegie Hall functioned as the college library from 1907 to 1963.

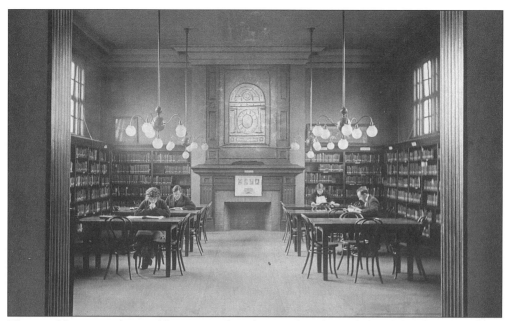

The new library was designed by New York architect Edward L. Tilton. The interior contained two reading rooms, the librarian's office, and a vault for rare books. The central rotunda still features sunken pillars and is topped by a stained-glass dome with a laurel wreath. The building functions today as the college museum of art.

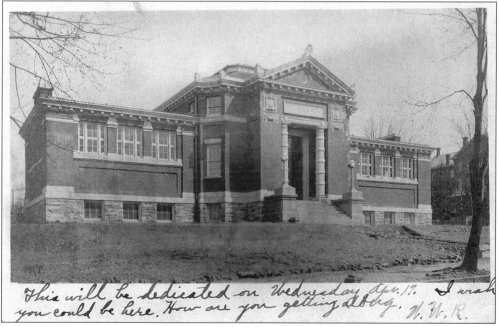

"Juniata's memorable celebration on Wednesday, April 17th, jointly commemorating the formal opening of the new Carnegie Library and the thirty-first anniversary of the founding of the college, has passed into contemporary history. [The events] contributed to the triumphant consummation of more than the ideals and plans and hopes of a quarter century ago could have grasped in a single dream." (*Juniata Echo*, May 1907.)

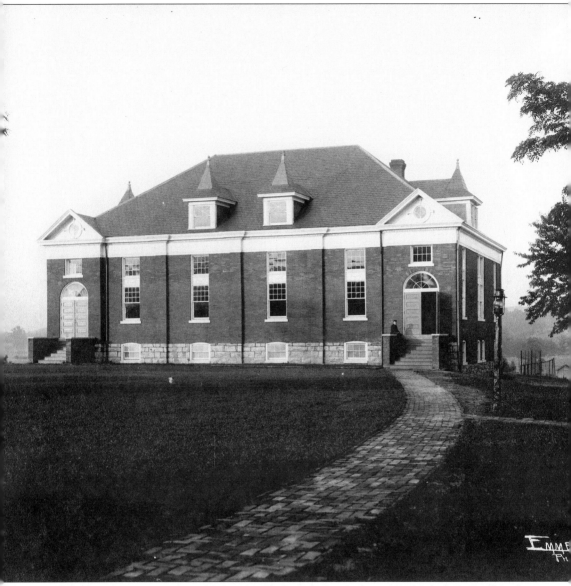

The first gymnasium was established by Professor S.B. Heckman in the basement of Students' Hall in 1896. The new gym, now referred to as the "old gym," was dedicated in 1901 in celebration of the college's 25th anniversary. The first athletic field was built in 1899.

Four
SCHOOL SPIRIT
AND TRADITIONS

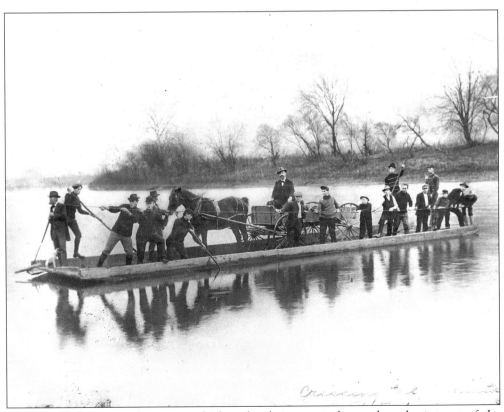

"Among all the arts and sciences which make their practical appeal to the interest of the ambitious student, surely none is of more practical importance than the art of social adjustment." (C.A. Hodges, "The Advantages of the Small College," *Juniata Echo* 1900.) Professor Emmert, at the far left, leads this crossing of the Juniata River.

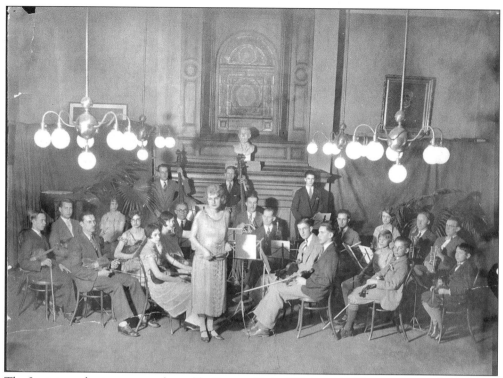

The Juniata orchestra was conducted by Donna Onita White in 1927.

These Glee Club members are about to take their act on the road.

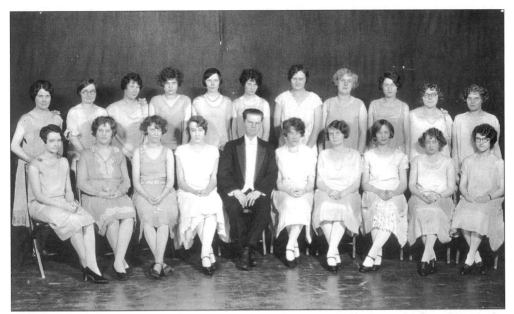

"A pleasant feature of college spirit is being developed when all the students gather on the campus and led by the Glee Club, all sing the latest popular college songs." (*Juniata Echo* 1900.) The Ladies Glee Club is featured in the photograph above.

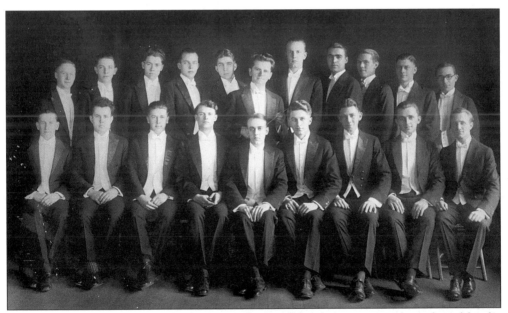

"During the last several years the life on College Hill has been very much awakened by the introduction of the singing of college songs. The college muse has inspired some of Juniata's sons and daughters to pour out their souls in rhythmic flow, and as a result we are glad to announce to the alumni, students, and friends of the college that a Booklet of College Songs in verse form has been published." (*Juniata Echo* 1900.) C.L. Rowland directed the Men's Glee Club in 1927

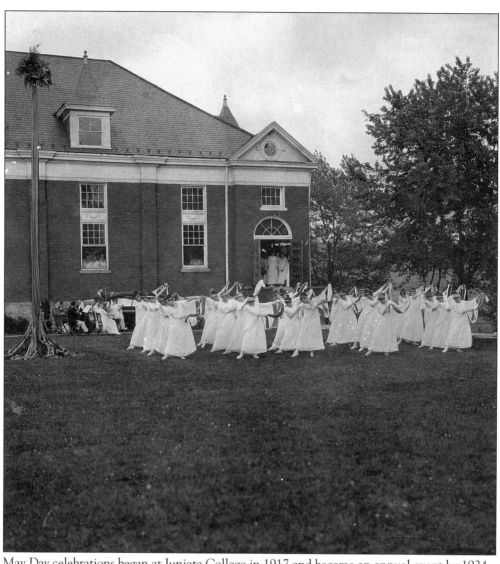

May Day celebrations began at Juniata College in 1917 and became an annual event by 1924.

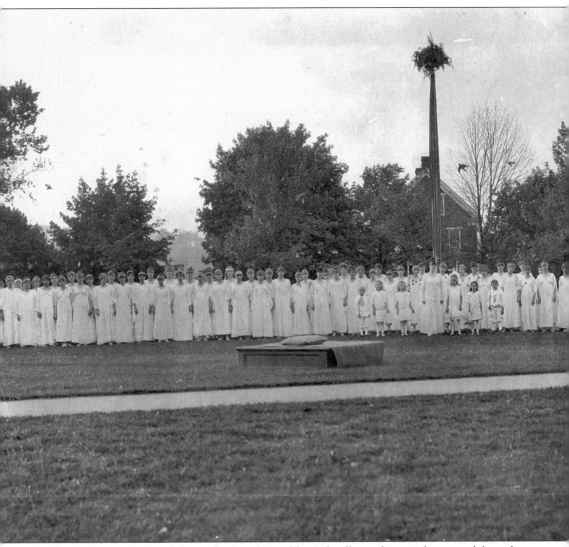

"To the accompaniment of the orchestra about fifty girls all in white with great, delicately colored butter-fly bows, marched in and formed various figures on the open-air stage." (From the first May Day activities, *Juniata Echo*, June 1917.) This photograph shows the May Day celebration of 1927.

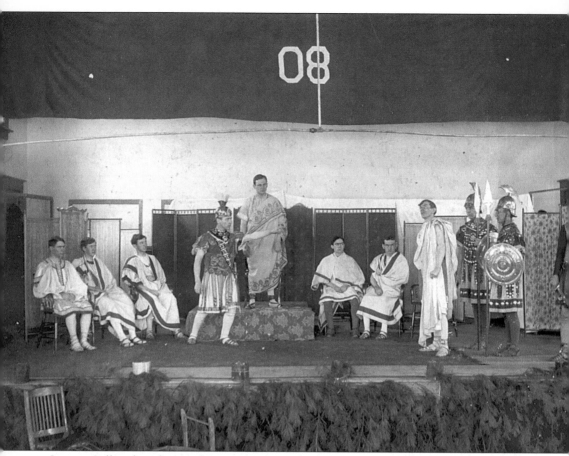

Juniata College has always taken an interest in the "classics" of theatre. This photograph shows the senior's play, February 21, 1908.

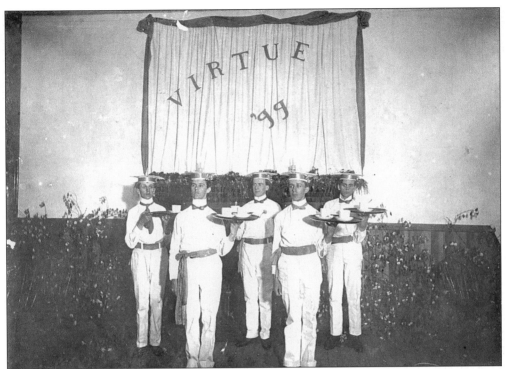

"The Senior reception on the 13th of May was delightful. The decorations in the class colors, purple and white were pleasing. The windows were filled with twigs of blooming dogwood, and the motto, 'Virtue' was tastefully placed over the large mantel." (*Juniata Echo*, May 1899.)

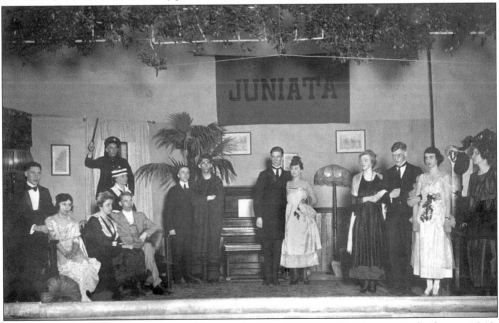

Theater was performed in the old gym before Oller Auditorium was built in 1940. This photograph shows the March 20, 1920 performance of the sophomore play *What Happened to Jones*.

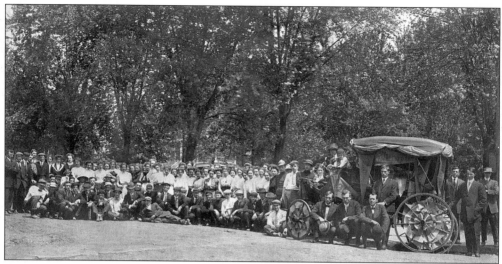

"From the beginning the battle raged hard but Juniata had a clear lead and State weakened terribly in rebuttal and practically conceded the question in their last rebuttal. When the decision of the judges was announced as unanimous for Juniata one wild cheer arose from the audience…" (*Juniata Echo* 1907.) The Juniata debaters won victory over State College in the spring of 1910.

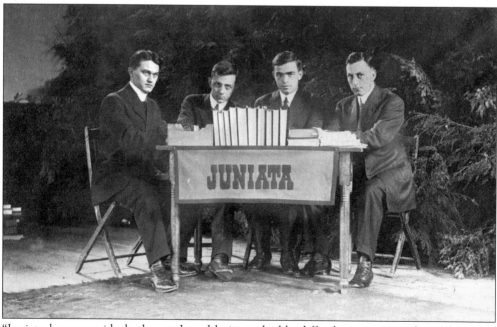

"Juniata has some ideals that make athletics a doubly difficult proposition, but debating is entirely in harmony with our nature and manifest destiny." (*Juniata Echo* 1907.)

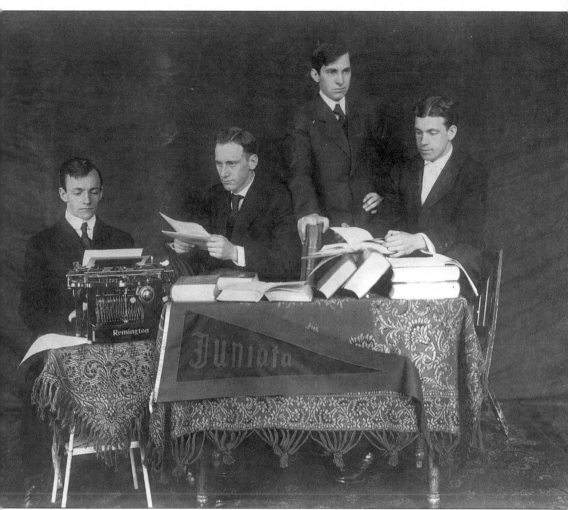

The debate team at Juniata was organized in 1902 and remained undefeated for ten consecutive years. The above image of the Juniata Debate Team was taken in 1910. The rally song for the debate team was sung to the tune of "There's Music in the Air." It went as follows: "Oh! Here at Juniata College we've a record in debate; Most any school would cherish, But none can imitate. Our debates have here been won, Though the questions weigh a ton; And we'll keep on winning still—We haven't had our fill."

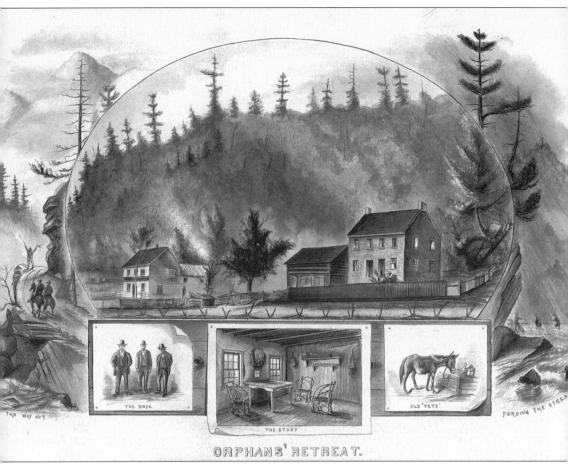

THE WAY OUT

THE BOYS.

THE STUDY

OLD "PETE"

FORDING THE STREA

ORPHANS' RETREAT.

In 1878, a smallpox epidemic in Huntingdon closed the school from January 13 to February 25. Three students from Ohio (all members of the Burchinell "Orphans" boarding club) did not receive the news about the closing in time from their return from holiday break. William Beery (a future faculty member), Benjamin Bowser, and Levi Stoner sought refuge in the mountains in an old hunting cabin known as the Forge. The boys returned to school safely after the epidemic had passed. An annual outing to visit this site, first by groups of students and later by the entire college community, began the tradition known as Mountain Day. This drawing of the Orphan's Retreat (attributed to David Emmert) recounts their ordeal.

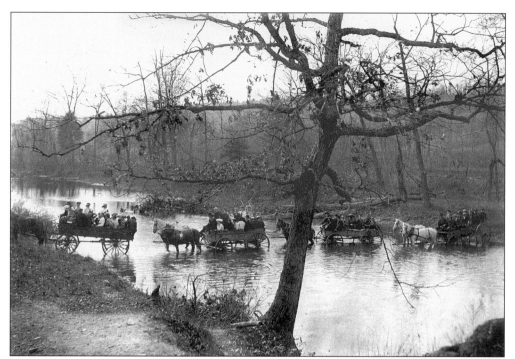

Mountain Day has long been a Juniata tradition. On an unannounced day, classes are canceled; students, faculty, administration, and staff head for the mountains for a day of relaxation, sports, and picnicking. Horse teams led by Mr. Martin Prough and Mr. James Wilson ferry students to spend the day picking chestnuts at Stone Creek for Mountain Day in this 1907 photograph.

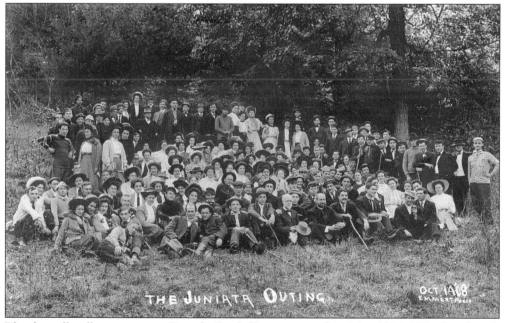

The first all college outing to Trough Creek Forge occurred in May 1896. H.B. Brumbaugh coined the expression "Mountain Day" in 1903 to commemorate the mountain exile of students during the smallpox epidemic of 1878. This Juniata outing was held in October 1908.

George Preston Hanawalt (class of 1922) poses before attending the Halloween Parade in Huntingdon, 1921.

"It is Hallowe'en, the season dear to young and old. And now from the dorms comes a motley crowd, painted clowns and sprightly fairies, ghosts and goblins." (*Juniata Echo*, November 1920.)

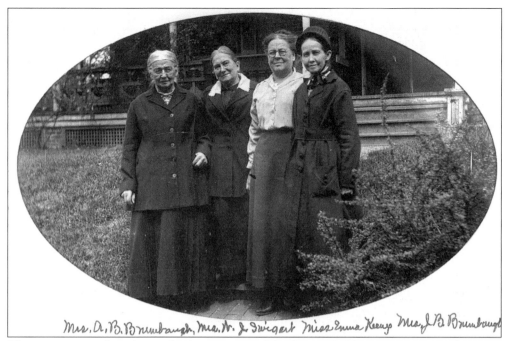

Mrs. A. B. Brumbaugh, Mrs. W. J. Swigart, Miss Emma Keeny, Mrs. J. B. Brumbaugh

This picture was taken during the first meeting of the Sisters Aid Society in Huntingdon. Four of the 17 charter members are present: Mrs. A.B. Brumbaugh, Mrs. W.J. Swigart, Miss Emma Keeny, and Mrs. J.B. Brumbaugh.

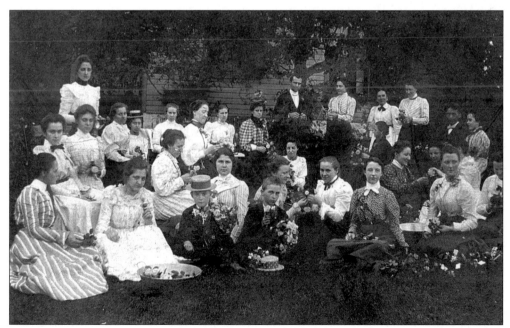

Members of the Sisters Aid Society make bouquets for the flower mission at Mrs. Swigart's. The society was first active in providing clothes for needy children. Men went from house to house measuring children, while the co-eds made the clothing.

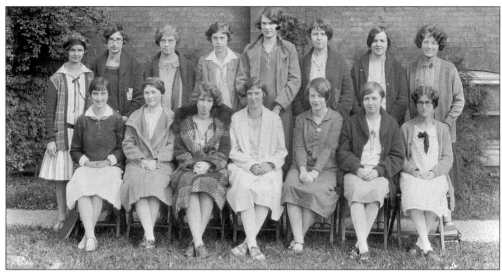

"The societies are canvassing for new members now—you will miss a great deal if you don't join a society." (*Juniata Echo*, January 1902.) This image shows the 1926–27 members of the Hiking Club, originally established in 1922.

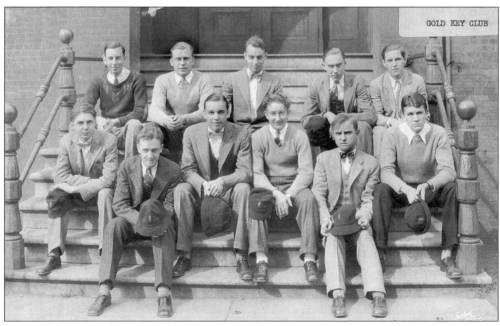

The Gold Key Club was established as an auxiliary of the Varsity "J" Club to promote general interest in athletics and to care for visiting players. Membership was made up of sophomore men who served as assistant managers to the various teams. This image shows members from 1929.

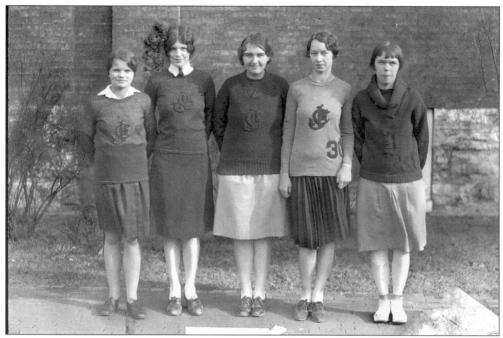

To recognize and encourage outstanding athletic ability, the "J" Club began in 1926. Members uphold the three virtues for which the club stands: Loyalty, Friendship, and Fair Play. The Ladies "J" Club appears in this 1929–30 photograph.

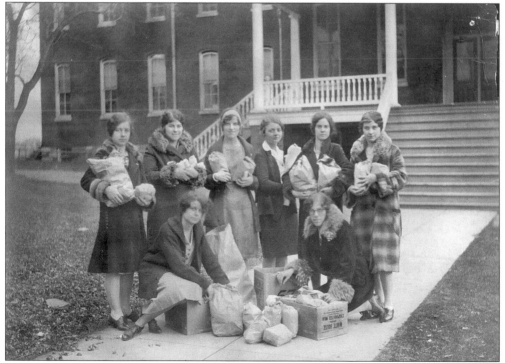

As part of their sponsored events, "Y" girls deliver Thanksgiving baskets to needy families, c. 1929. The YWCA was designed to enrich the spiritual and social life of young women.

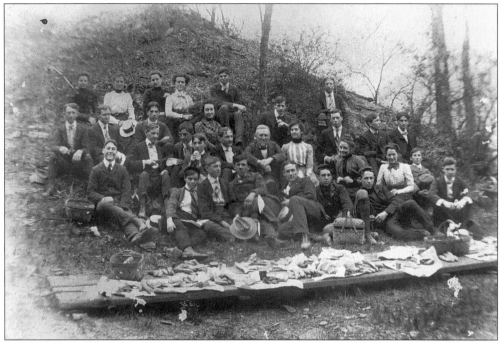

"What of the botanizing expeditions, when luncheon was spread in the mouth of the glen at the point of the ridge?" (D. Emmert, 1901.)

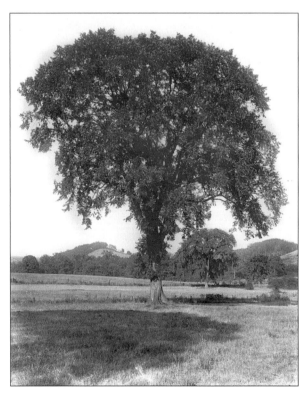

Smoking was prohibited on campus. This elm tree, or "The Ulmus," on the perimeter of the college, was frequented by smokers from Cloister residence hall, which was built in 1928.

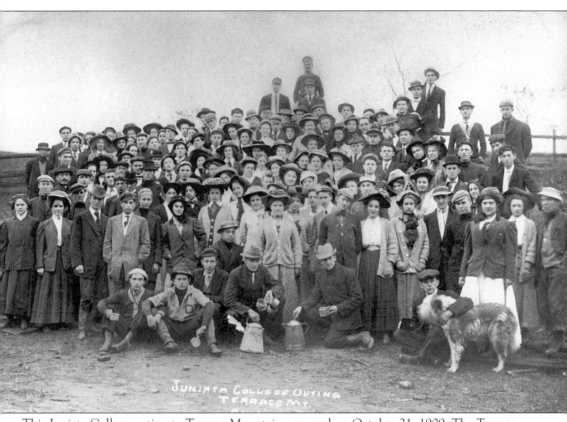

This Juniata College outing to Terrace Mountain occurred on October 21, 1909. The Terrace became a favorite outing site, second only to the Forge.

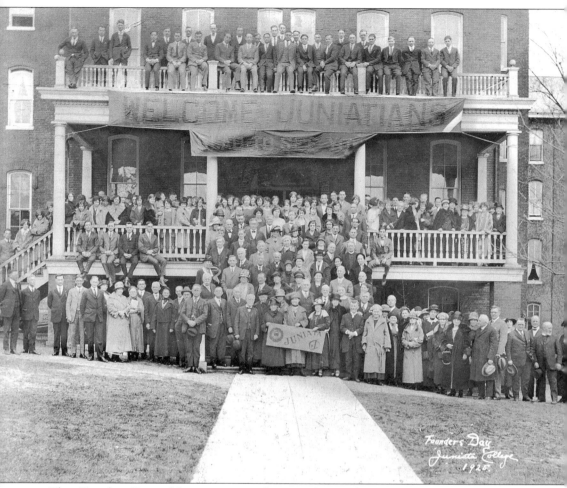

This Founders Day celebration occurred in 1925. Founders Day is celebrated annually to commemorate the establishment of this institution on April 17, 1876.

Five

TEAM SPIRIT

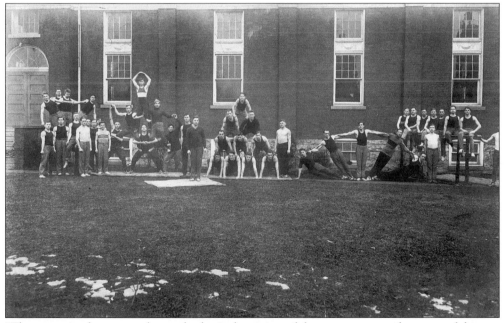

"The necessity for a more thorough physical training of the young men and women of this age is becoming more and more pronounced and the want of it recognized by the thoughtful." (Dr. A.B. Brumbaugh, *Juniata Echo*, August 1891.)

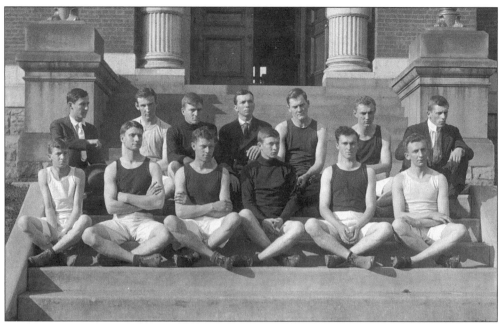

The track team of 1911 posed for a group photograph on the steps of Carnegie Hall.

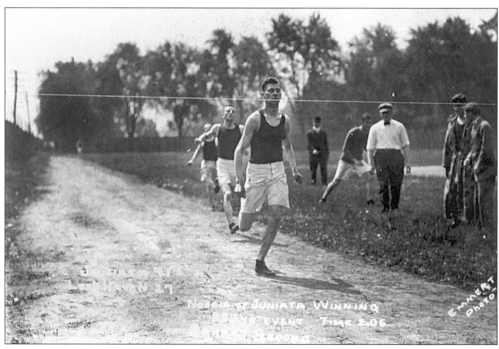

"Juniata 91; Lock Haven 27." Norris of Juniata is winning the 880 yard event in this image; his time was 2.06.

"During the last three years Juniata has set a remarkable pace in track, constantly smashing records and winning meets." (*The Scout*, 1926–27.) This picture of a track team member was taken in 1927.

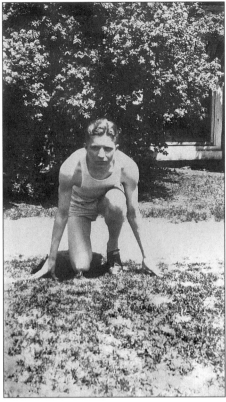

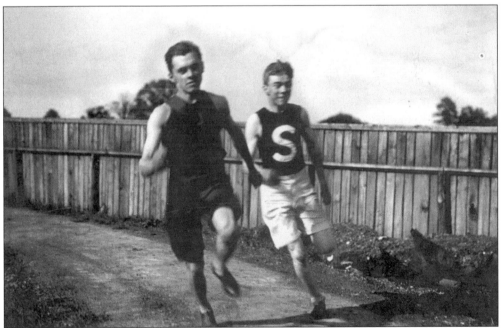

"Track candidates have been sinking their spikes into the cinder for several weeks. The result is that a number of men are in the pink of condition for the Spring Championship Meet." (*Juniata Echo*, April 1917.)

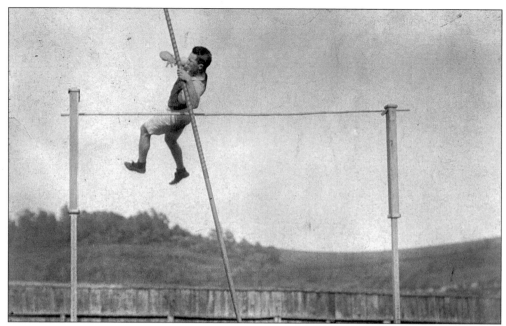

Undergraduate Harry Frederick Manbeck pole vaulted 9 feet, 4 inches.

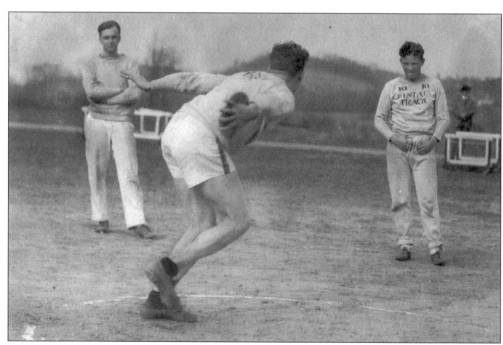

"Perhaps Juniata's greatest successes in sportdom have been achieved in track. For years the Indians have been undefeated." (*The Scout*, 1929.)

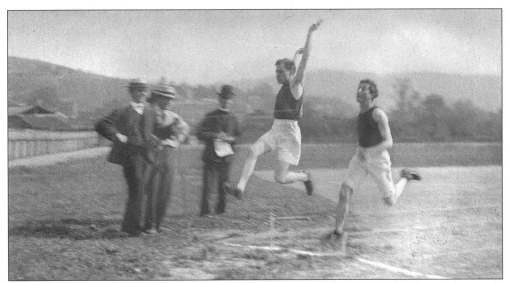

For years, Norman J. Brumbaugh held the record for running the 100-yard dash in ten seconds. And for years the comment was made, "And his father held the stop watch."

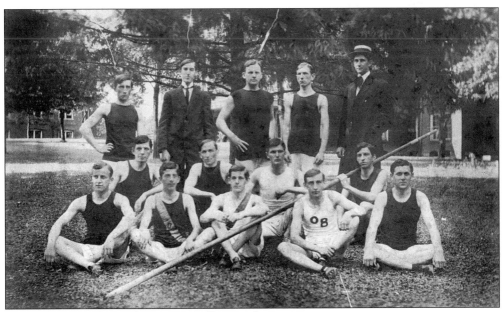

This 1908 image shows the Juniata College track team.

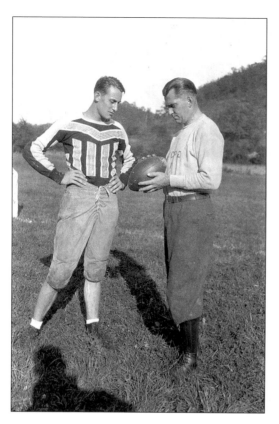

"As soon as the air begins to taste of frost and grow pungent with cider apples—as soon as the clear cut scarlet of turning maples splashes across the green—as soon as Thanksgiving turkey and the 'fixins' cast their luminous glow over the background of our consciousness—there's only one game that hits the note of the season—football!" (*Juniata Echo*, October 1920.)

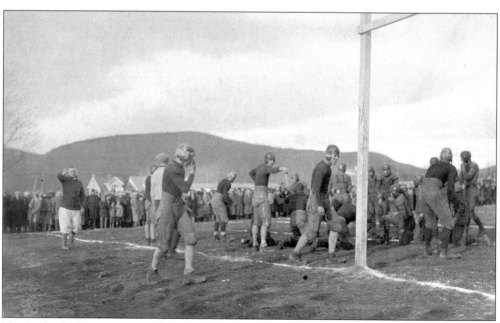

Varsity football is in action at Juniata College in this 1922 picture.

"Football at Juniata, like most colleges, is the giant of the whole athletic program." (*The Scout.*)

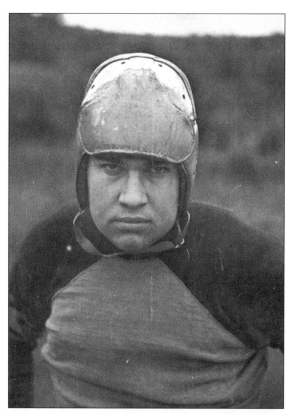

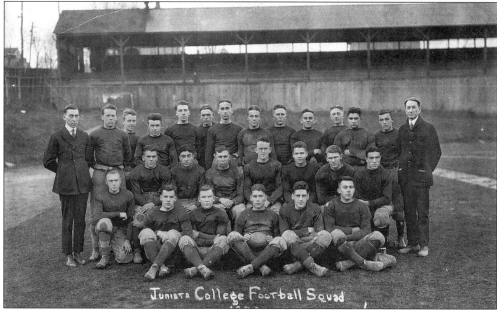

In 1920, the first year a Bachelor of Science degree became available, the faculty voted to approve football as a recognized sport at Juniata College. However, no money was available to support the team. Students raised $600 and sent fellow student Roy Wolfgang to New York to buy equipment. This image shows the Juniata College football squad in 1920.

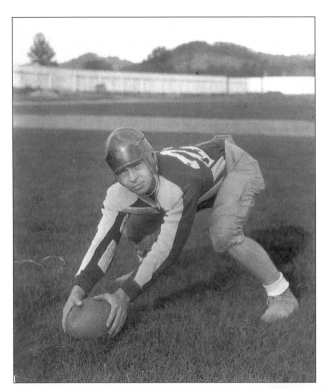

Paul Fisher, of the Juniata College football team, is shown here, *c.* 1913–14.

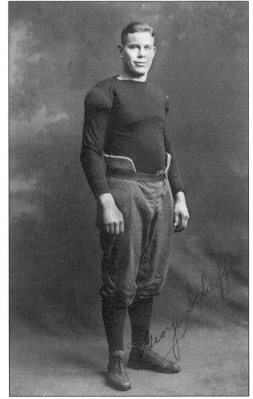

"Base-ball has quietly given way to foot ball, and our boys may now be seen dressed in blue-drilling blouse and trousers, fighting their manly contests for exercise and glory." (*Juniata Echo*, November 1896.) Team player George Schaeffer posed for this photograph in 1918.

"Stand Up and Cheer," the pep rally song for the football team, reads as follows: "Stand up and cheer; Stand up and cheer for Juniata; For to-day we raise the Blue and Gold above the rest. Our boys are fighting; For they are bound to win the fray; We've got the team, we've got the steam; For this is Juniata's day."

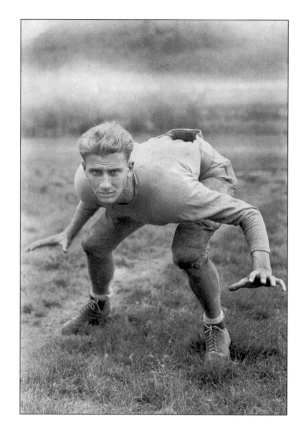

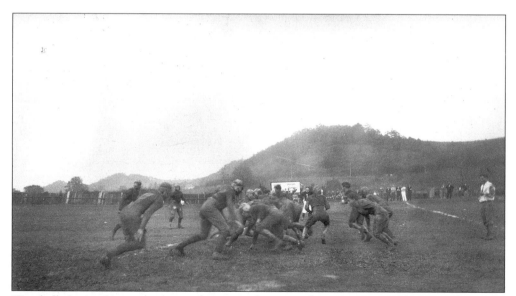

"Football, Juniata's youngest sport has never been on the win margin. However, this year's schedule is a ringer and with promising new material it should be a success." (*The Scout*, 1926–27.) Juniata's football team can be seen here in action, *c.* 1926.

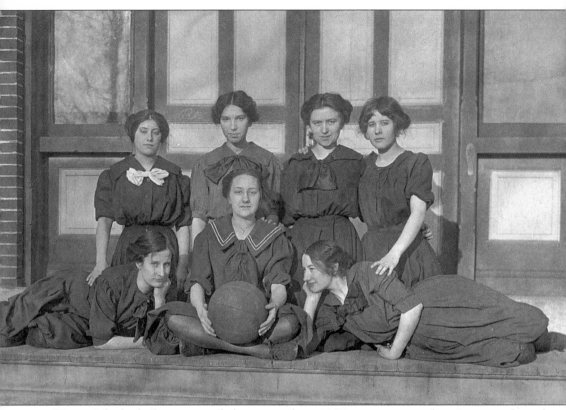

Women's basketball was suspended temporarily in 1917 as it was viewed as, "unscientific and unpedagogical." It was reinstituted in 1918. "After a year's rest the girls through persistent effort have obtained permission to play basket ball again." (*Juniata Echo*, January 1918.)

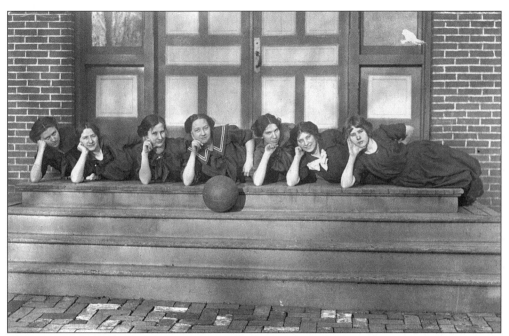

The women's basketball team at Juniata College poses for a photograph.

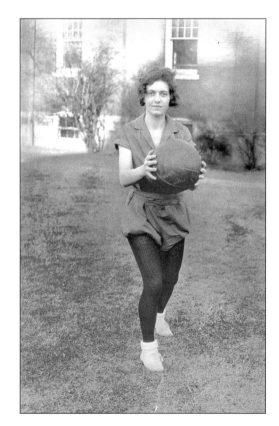

"Basket ball is the latest addition to the games on the ladies' athletic field. Some of the ladies have become quite expert in pitching the inflated leather ball, about fifteen inches in diameter, into the baskets which stand ten feet from the ground." (*Juniata Echo*, November 1899.)

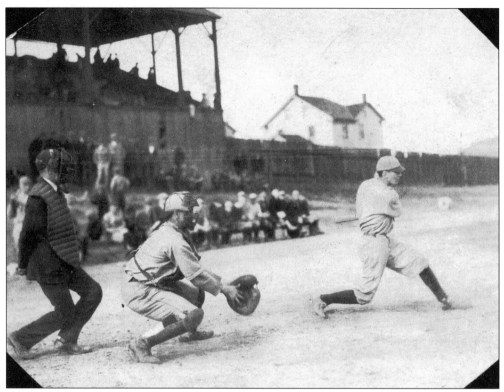

"Intramural baseball was played and played vigorously with much rooting and razzing." (Dr. Norman J. Brumbaugh, 1890.)

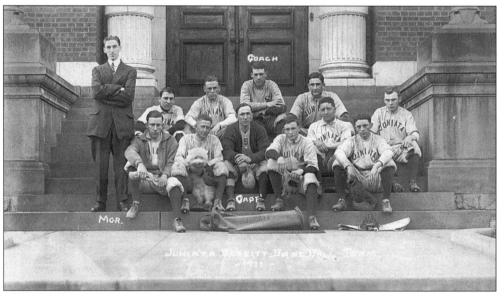

Baseball is the oldest organized sport at Juniata College. A baseball team was first organized in 1899, but it was not until 1903 that baseball became a competitive intercollegiate sport. Juniata won its first baseball game in 1899 against a local team, Petersburg, 10-2. This 1911 photograph shows the Juniata Varsity baseball team.

This baseball player posed for a photograph during the 1927 season.

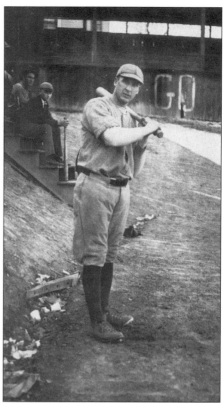

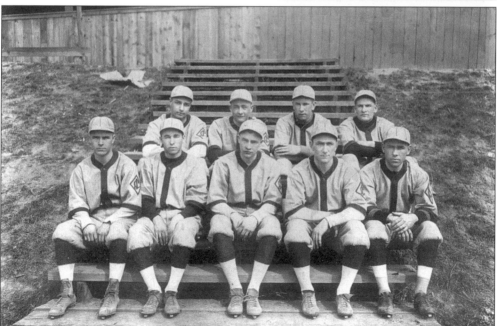

"Base ball is serving as a means of healthful recreation to the lovers of the national game, and many of the boys are becoming quite expert with the leather sphere." (*Juniata Echo*, April 1896.) This image shows the 1914–15 baseball team.

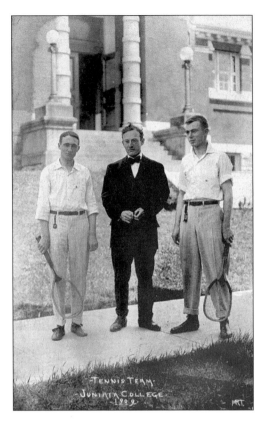

"Tennis has captured the hearts of many new players, and the interest manifested in this scientific and exhilarating game surpasses any previous record at Juniata." (*Juniata Echo*, October 1902.) This tennis team at Juniata College was photographed in 1909.

Tennis had been a popular sport on Juniata's campus before the first intercollegiate tennis match in 1911. Gettysburg won 3-2.

"Base ball and tennis seem to be the only athletics on Juniata this term. A rumor of foot-ball was in the air, but the October winds blew it over the hills and far away." (*Juniata Echo*, October 1898.)

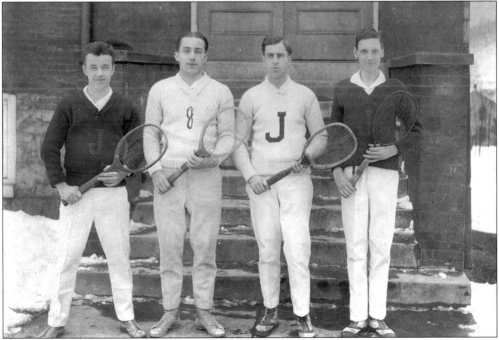

The tennis team at Juniata College in 1922 consisted of Ralph Brumbaugh, Roy Wolfgang, Jessie Stoyer, and Calvert Ellis.

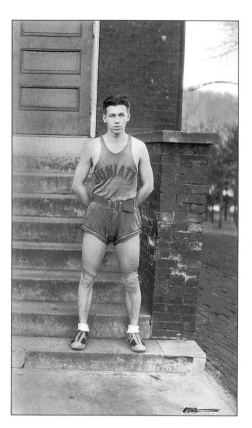

"Gentle breezes laden with the spirit of basket ball have already been wafted across the campus and in view of these early signs one is safe in saying that this year's spirit will far exceed that of any other." (*Juniata Echo*, July 1908.)

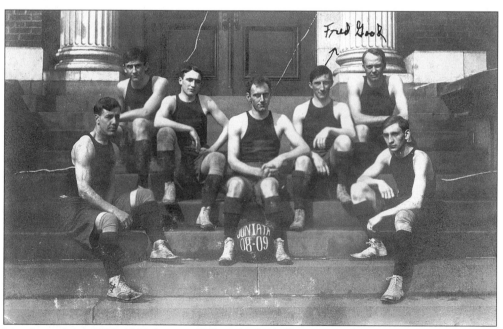

Members of the 1908–1909 Juniata College basketball team can be seen above. "This is the bunch which tried to hold up the standard of Juniata," stated the reverse of the postcard.

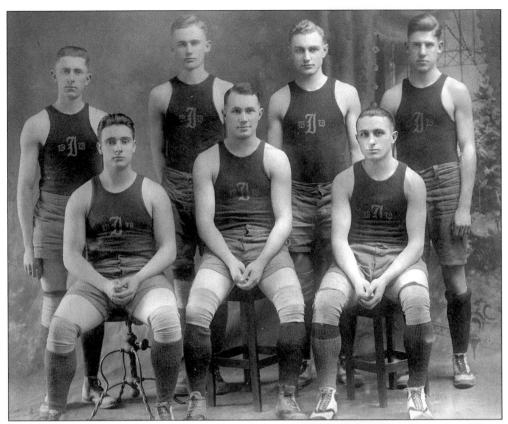

"The basket ball season is now in full swing with all eyes focused on Coach Putt's protégés." (*Juniata Echo*, January 1917.) The 1917 Juniata College basketball team appears above.

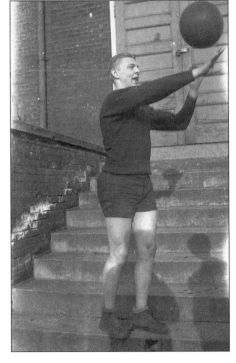

"Clean Sport—Juniata believes in the Theodore Roosevelt motto: Play the game, don't foul, hit the line hard. In all contests, athletic or literary, the goal of the Juniata student is not to win, but to play the game fair. Juniata will play hard to win, but she would rather go down to defeat than gain any honor unfairly." (*Juniata Echo* 1922.) This basketball team member played during the 1926 season.

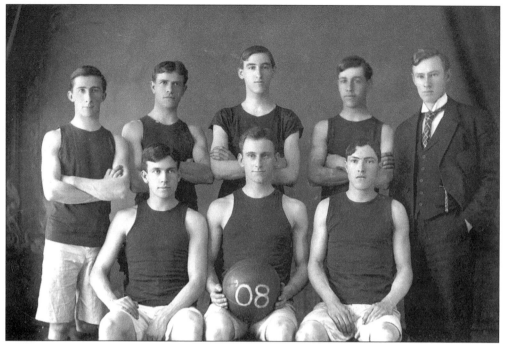

"When Juniata boys determine to 'do things,' they do them in grand style. Both the college and the preparatory teams have been practicing faithfully for several months, and now they are in good condition to play fast ball. They certainly have the hearty support of all the students." (*Juniata Echo*, February 1908.) The 1908 basketball team appears above.

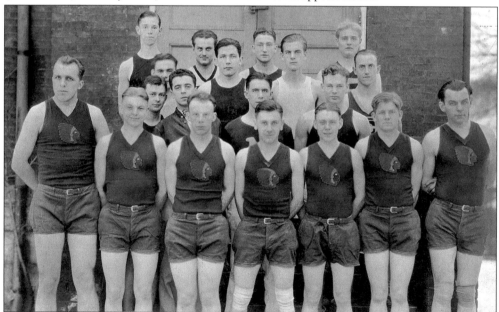

"In basket ball Juniata enjoys an enviable reputation. The last two seasons have been especially successful. Decided wins over W. and J. and Catholic U. climaxed last year's schedule. Intramural basketball is encouraged." (*The Scout*, 1926–27.) This image shows the men's basketball team at Juniata College, *c.* 1927.

Six

FILLING OUR DAYS
WITH FRIENDSHIP

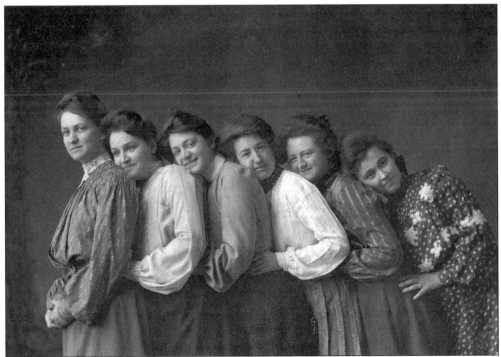

"This is an age of wonderful things." (*Juniata Echo*, 1891.)

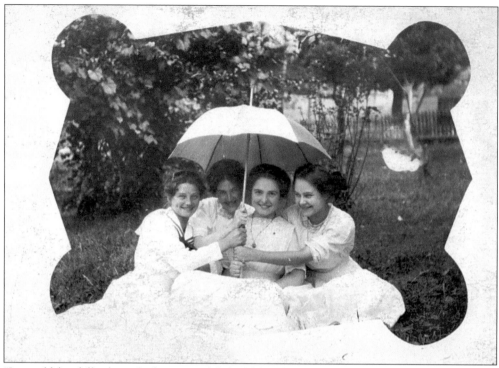

"It would be difficult to find a more delightful locality for walks than Huntingdon and the surrounding country afford." (*Juniata Echo*, October 1908.) Four women under an umbrella enjoy a timeless friendship at Juniata.

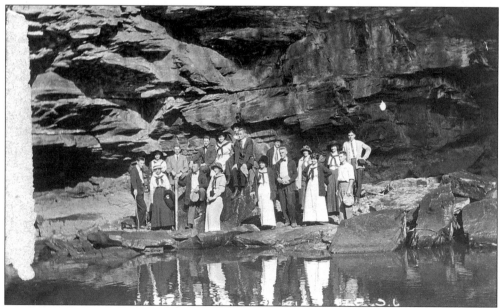

The 1914 Mountain Day excursion went to Copper's Rock, the Old Forge. Students continue to visit the site where three of the "orphans" were exiled during the smallpox epidemic in Huntingdon, during the winter of 1878.

"Who will fill their places? Will you? Think of it friends, you need the excellent instruction which Juniata gives." (*Juniata Echo*, June 1911.) Members of the class of 1911 appear above.

"That every young woman should show herself a lady in all social intercourse and in all public assemblies is the rightful expectation of the institution and of all good people everywhere." (*Ideals*, formulated and published in 1922.)

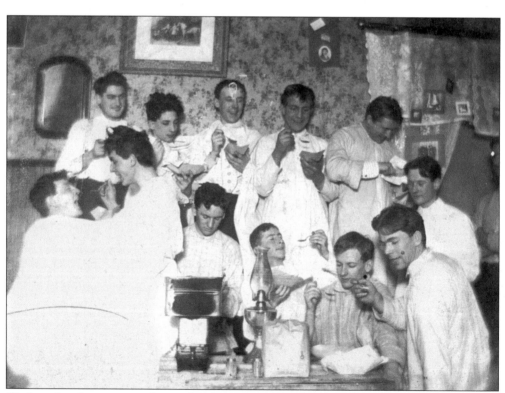

"[Informal parlor receptions] are a decided improvement on the sociables . . . They familiarize the young people with the customs of refined society, and educate their manners into a refinement that will prove a pleasure to them." (*Juniata Echo*, February 1891.)

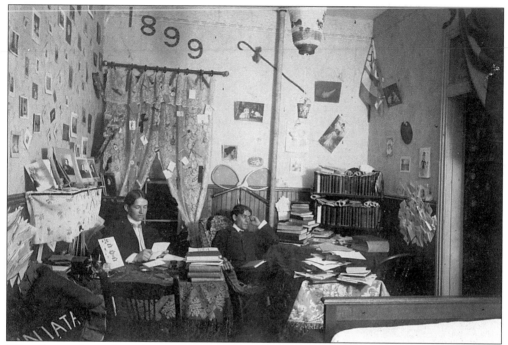

"The thesis subjects have been given and the seniors are busy with their topics." (*Juniata Echo*, January 1899.)

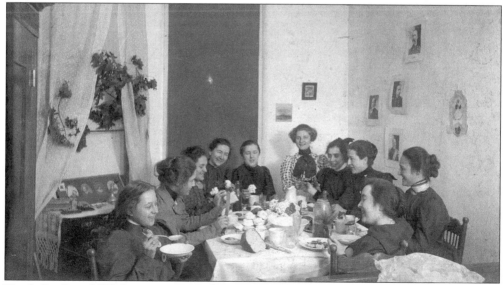

Ten ladies from 1898 dine in a private dorm room.

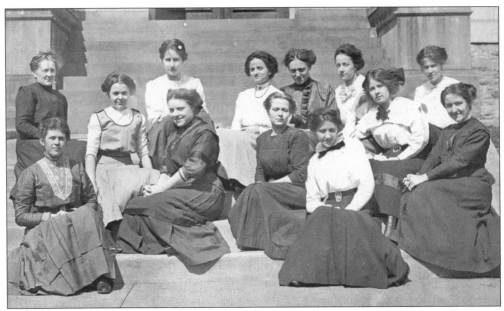

In this image of the Ladies' Hall, taken on March 21, 1911, the following women can be seen: Grace Stayer, Marguerite Young, Laura Siegel, May Stevenson, Mildred Neff, Faye Houck, Nellie Kerr, Edna Metz, Miss Adams, Pearl Hess, Ella Sheeley, Jeanette Reim, and Ethel Sallenberger.

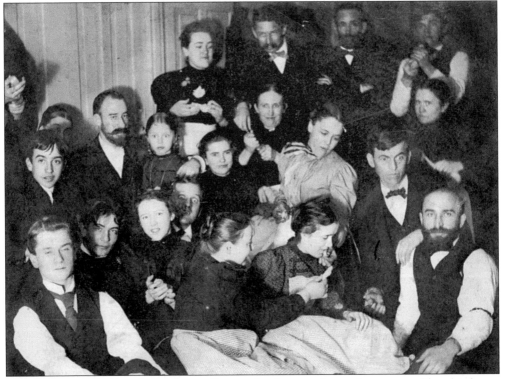

A taffy party was held in the kitchen at Juniata for those students who were unable to go home during the winter holidays of 1899.

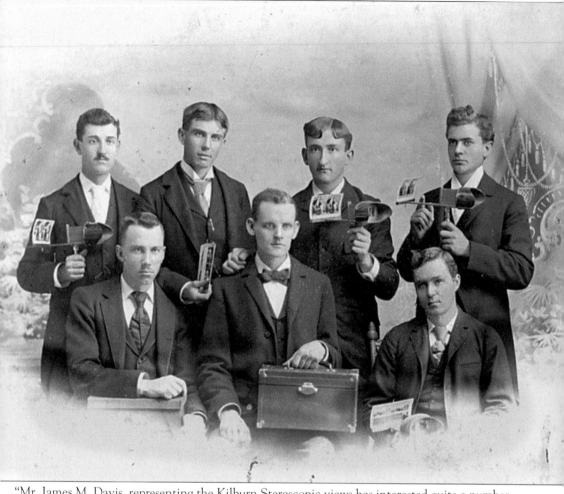

"Mr. James M. Davis, representing the Kilburn Sterescopic views has interested quite a number of our boys in his business." (*Juniata Echo*, May 1896.) A number of Juniata students made money for their college education through the sale of stereoscopes.

For Exam Week students adapted the following lyrics to the tune of "Three Blind Mice:" "Faculty, Faculty; Where can they be? Where can they be?; They're victims all of the Blue-Book craze, In misery spending their nights and days; Who cares if they never get out of the maze? Faculty!" (Jubilee Edition, *Songs of Juniata*, 1926.)

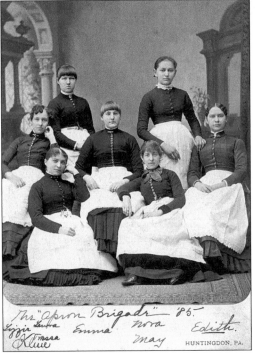

The *"Apron Brigade"* '85.
Lizzie Laura Emma Nora Edith.
Kline Tessa May HUNTINGDON, PA.

The "Apron Brigade" of 1885 posed for this photograph.

"Some time ago a fund was started to furnish a Ladies' parlor, or room for the use of the lady students to be a pleasant place where they could meet each other, away from distracting annoyances." (*Juniata Echo*, June 1892.)

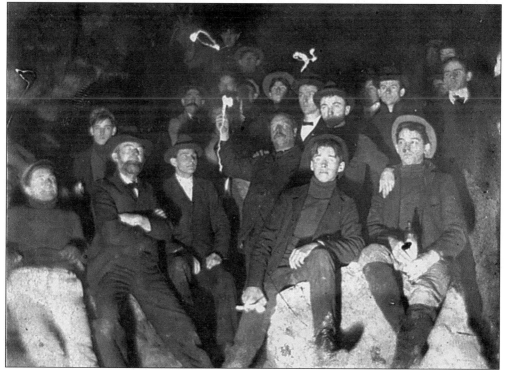

Juniata boys gathered in Mapleton Cave, February 10, 1907.

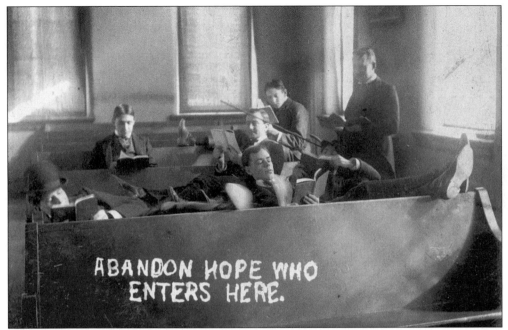

ABANDON HOPE WHO
ENTERS HERE.

"Abandon Hope Who Enters Here." The reverse reads, "one of Dr. Lyon's classes." Dr. Lyon taught Latin and English from 1896 to 1899; he composed the first alma mater in 1898.

The cliffs attracted Juniatians in 1898 as they do today. The first outing during the fall term to the cliffs was led by Professors I. Harvey Brumbaugh and O.P. Hoover on Saturday, September 17, 1898.

"Very few are the persons who do not at most times desire the company of their fellows."
(I. Harvey Brumbaugh, *Juniata Echo*, May 1896.)

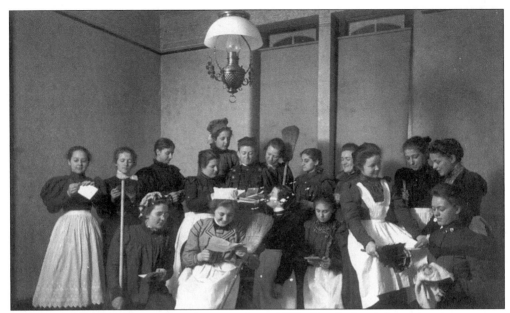

The distribution of mail on a Saturday morning in 1899 offered a break from cleaning.

"The College desires that the young people grow in the graces of modest dressing, wholesome speech, and common courtesy under all circumstances." (*Ideals*, formulated and published in 1922.)

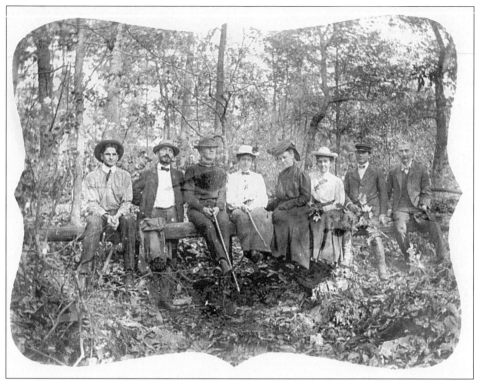

"By unanimous action of the faculty, entire freedom of the campus among the boys and girls is allowed every day from four o'clock until supper. How short these long periods sometimes seem." (*Juniata Echo*, October 1902.)

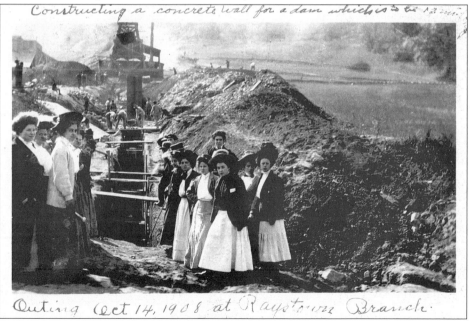

"Constructing a concrete wall for a dam which is to be twelve miles long." This outing occurred on October 14, 1908, at Raystown Branch.

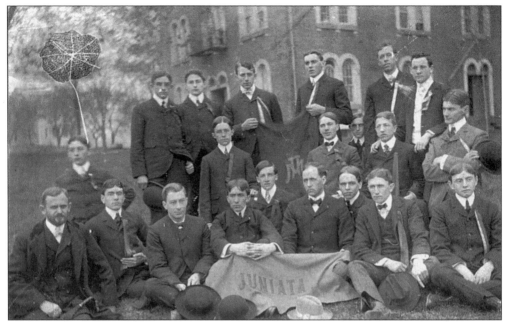

"We propose to maintain close personal touch with our student body. We want to know these young men and women. We want to counsel with them. We want to enter vitally into their life purposes, and help develop those qualities of mind." (Inaugural address of M.G. Brumbaugh, January 29, 1925.)

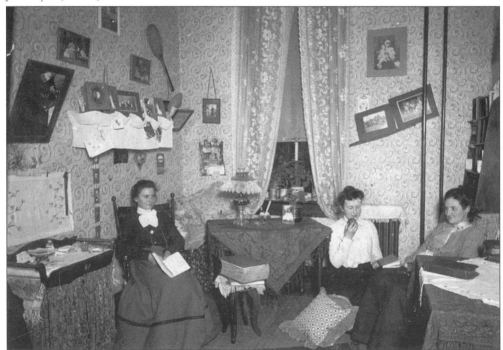

"As soon as you arrive on College Hill, you should report to the Dean's office for your room assignment. (We trust you've made your reservation earlier.)" (*The Scout.*) Room 93 is shown here during the 1902–1903 school year.

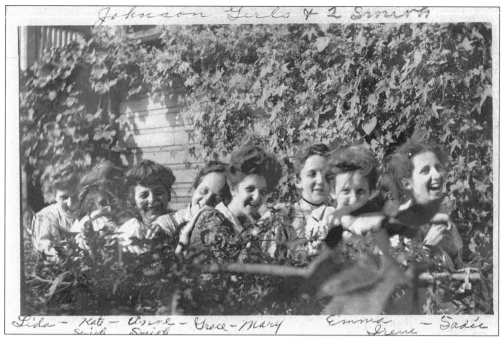

Johnson Girls & 2 Smith

Lida — Kate — Osire — Grace — Mary — Emma — Irene — Sadie
Smith Smith

"This term as never before there is a general satisfaction with college life and a mingling of cliques. Indeed one can almost say that there are no cliques. Strolls, socials, and society work are bringing about a much better condition of affairs." (*Juniata Echo*, May 1902.)

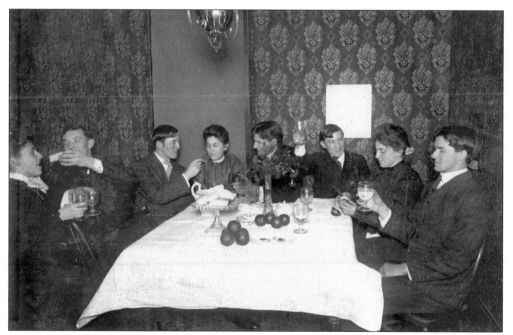

"Very many scholarly men fail miserably in their efforts to entertain in conversation . . . it is the duty of every one to cultivate the talent that is in them, and so contribute something to the conversational fund." (*Juniata Echo*, June 1892.) Students gathered to dine, *c.* 1905.

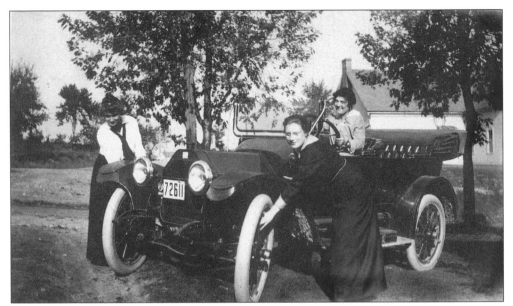

"All women may be permitted to go auto-riding in the afternoon with an approved chaperone." (*The Scout*, 1926–27.)

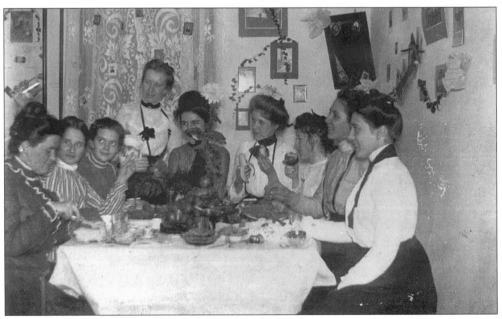

Friends gather to dine in a woman's dorm room, *c.* 1902–1904.

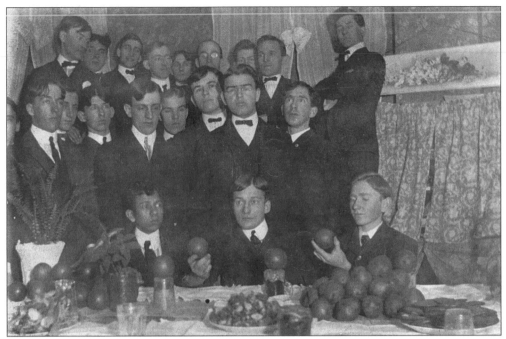

"The college halls were crowded to their utmost with friends, with old students, and with alumni who came back to renew old friendships and to partake once again of those fraternal feasts of which only college men and women know." (*Juniata Echo*, June 1897.)

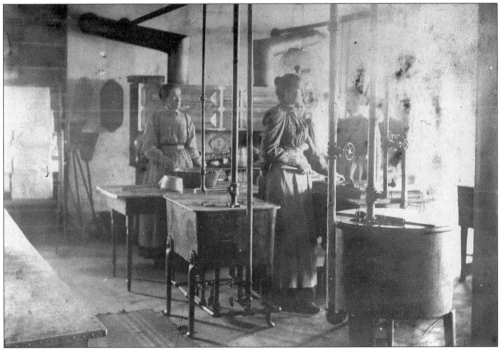

The laundry room for the college can be seen in this photograph. During the fall of 1917, a fire took place. "Fire in the laundry room. Students are requested to leave their clothing unpressed and to eat cold 'eats,' if any." (*Juniata Echo*, October 1917.)

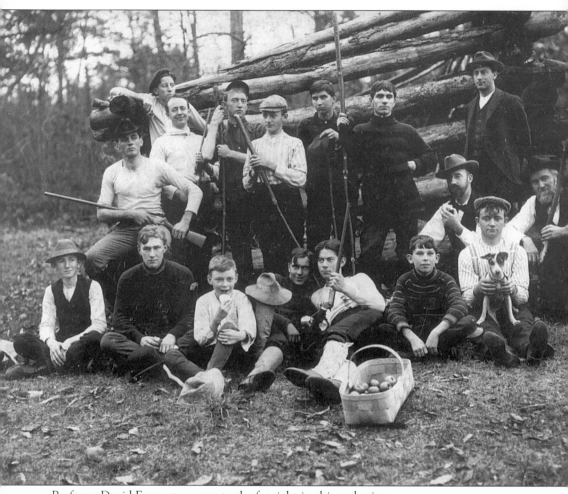

Professor David Emmert appears to the far right in this gathering.

Seven
THOSE WHO HAVE
COME BEFORE US

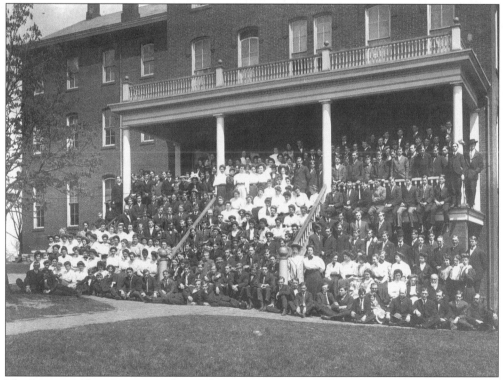

The Juniata "Alma Mater" reads as follows: "To Juniata, College dear; In praise we raise our song; The place of loyal hearts and cheer; Which we have loved so long; We love the pathways to and fro; The classrooms and the halls; We'll ne'er forget, tho far we go; The days within her walls." (Dr. George Lyon, 1898.) The Juniata student body is shown here in 1907.

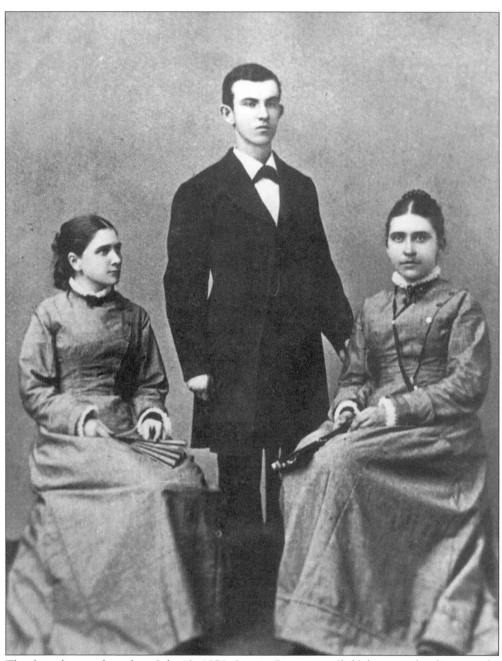

The first class graduated on July 10, 1879. Linnie Bosserman (left) became the director of a school for Native Americans in Oklahoma; Gaius Brumbaugh (center) earned his M.D. and opened a private practice in Washington, D.C.; and Phoebe Norris (right) also earned her medical degree and became a physician in Washington.

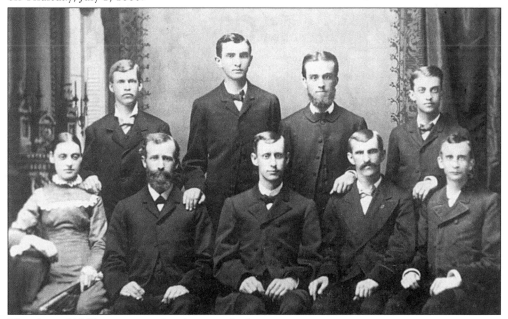

COMMENCEMENT EXERCISES.

Evening Session---Half-past 7 o'clock.

PROGRAMME :

Music—Anthem—'As Pants the Hart.'
SCRIPTURE READING.—PRAYER.
Music—Anthem—'Upon the Mountains '
Essay : *Why ?* . Essie O. Bosserman.
Oration : *The Unpainted Canvas,*
W. Howard Flory.
Music—Solo and Chorus,
'I'm Wandering in Distant Lands.'
Essay : *To-morrow, the Flowers will Fade,*
Clara E. Horn.
Oration : *Shakspeare,* W. D. Langdon.
Music—Quintet—'Queen of the Valley.'
Oration ! *"I have indeed gathered a few pebbles on the shore, but the great ocean of knowledge is still before me."—Newton.* H. P. Moyer.
Oration : *The Prophecy of Poetry*
W. B. Yount.
Music—Ha! ha! We've stemmed the stream
Address, and Conferring of Degrees,
ELD. JAMES QUINTER.
Music—Quartet,
'Good-Night, Gentle Folks.'

☞ *Institute or Teachers' Term for 1880,* will open July 19, and continue Six weeks. Regular Fall Term opens Aug. 30, 1880. For particulars, address J. H. BRUMBAUGH, P. O. Box 290, Huntingdon

BRETHREN'S

NORMAL COLLEGE.

CLOSING EXERCISES
—AND—
COMMENCEMENT.

NORMAL CHAPEL,
HUNTINGDON, PA.,
Thursday, July 1st, 1880.

Graduates in Normal English Course :
ESSIE O. BOSSERMAN, Polo, Mo.; CLARA E. HORN, Roseville, Ohio; WILL D. LANGDON, Huntingdon, Pa.; W. HOWARD FLORY, Longmont, Col.; H. P. MOYER, Mainland, Pa.; W. B. YOUNT, Korner's Store, Virginia.

Musical Director, . . WM. BEERY.
Organist, . . Miss CLARA WEBB.

Journal Print, Huntingdon, Pa.

The commencement program for closing exercises of the Brethren's Normal School occurred on Thursday, July 1, 1880.

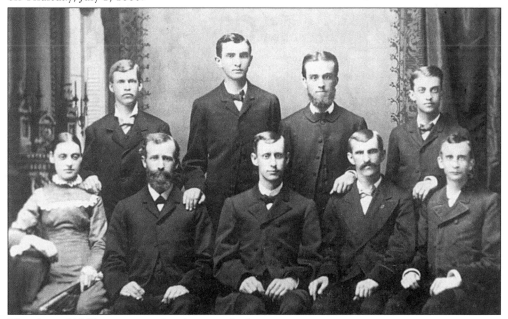

The class of 1882 appears in the photograph above.

The class of 1884 consisted of E.R. Heyer (left), William S. Price (top), and L. Howard Brumbaugh (right.)

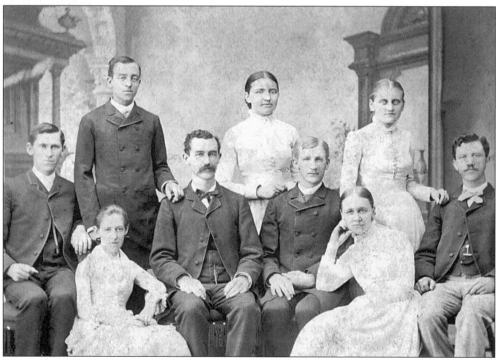

This picture shows the class of 1885.

The following students graduated in the class of 1887: (sitting) Frank Baker, Laura Norris, and Granville Brumbaugh; (standing) Allen Myers.

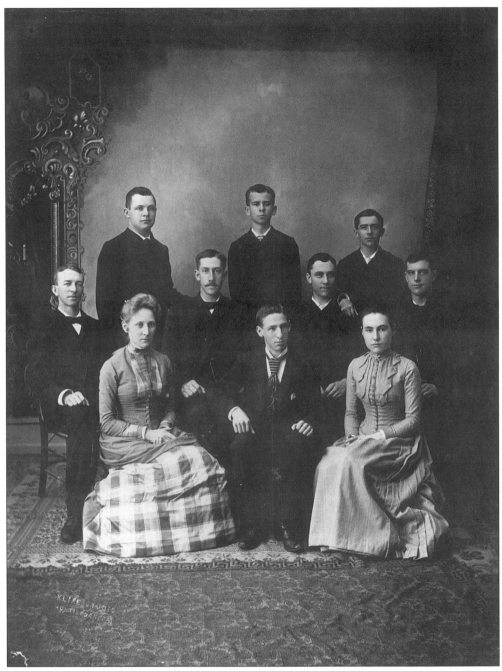

The class of 1888 consisted of John K. Brumbaugh, Robert L. Himes, Henry P. Fahrney, Christian Swigart van Dyke, Henry R. Gibble, D.B. Showalter, Noah J. Brumbaugh, Jennie S. Newcomer, John B. Oller, and Grace Quinter.

The class of 1890 included, from left to right, the following students: (front row) A.C. Wieand, Ada R. Linter, and William W. Cupp; (back row) E.M. Howe and Charles C. Ellis.

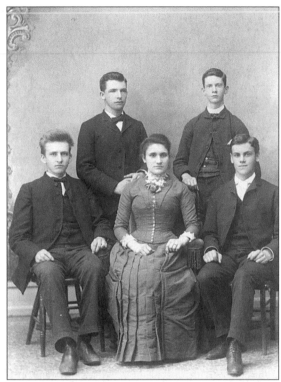

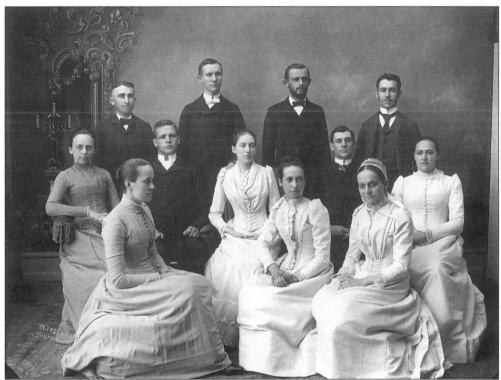

The class of 1891 posed for this photograph.

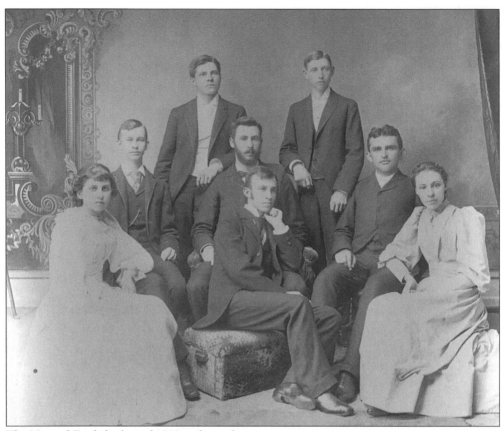

The Normal English class of 1893 is shown here.

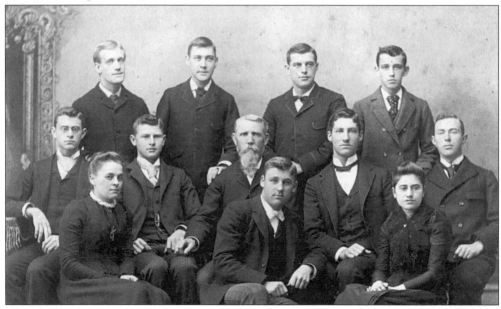

This photograph of the Juniata Business College class of 1893 was taken during the winter of 1892. Each member received a diploma upon completing the course the following year.

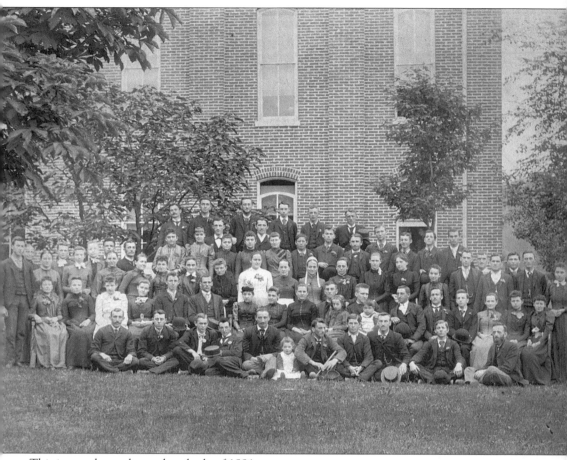

This image shows the student body of 1891.

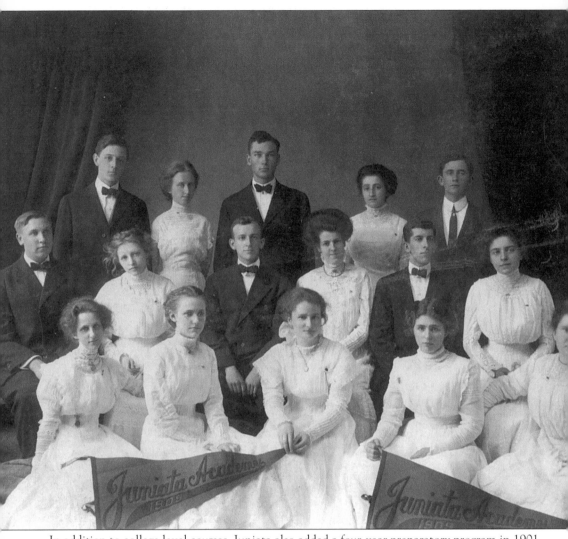

In addition to college level courses, Juniata also added a four-year preparatory program in 1901, called the Academy. This image shows the Juniata Academy class of 1909.

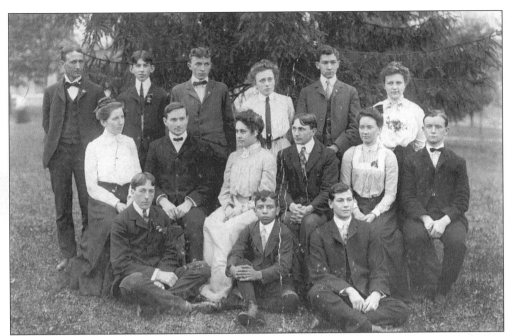

"The Juniors of this year naturally felt that they had worked harder than any of their predecessors. Juniors always do, you know." (*Juniata Echo*, June 1897.) This Junior class was photographed in 1903.

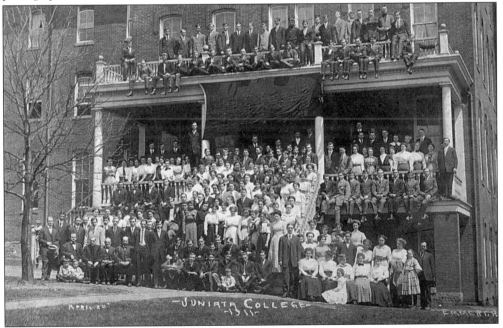

The lyrics "WHEN?" are sung to the tune of "When Cherries Grow on Apple Trees." "When Seniors gain some dignity; And Juniors lose their strut; When Faculty begin to see; The advantage of a cut. When little troubles turn to joys; And smiles replace the pout; Then all the freshie girls and boys, May have their one-night-out!" (Jubilee Edition, *Songs of Juniata*, 1926.) This Juniata College student body was photographed in 1911.

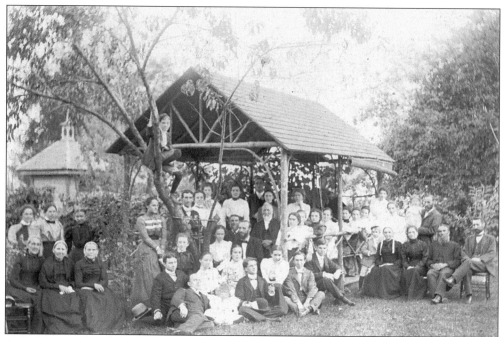

"The patriotism of Juniata's students manifests itself most forcibly in the reunions held during the summer vacations." (*Juniata Echo*, November 1899.) This Juniata College reunion was held in Waynesboro, Pennsylvania, on August 28, 1899.

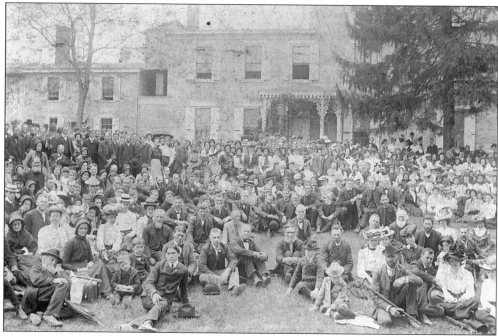

"During the Annual Meeting Harrisburg had the largest crowd ever in the town. The street car lines were almost blocked by the great crowds and every place was crowded with people. It was a happy time and nearly all of Juniata was present." (*Juniata Echo*, June 1902.) The Juniata Annual Meeting on May 19, 1902, took place in Harrisburg.

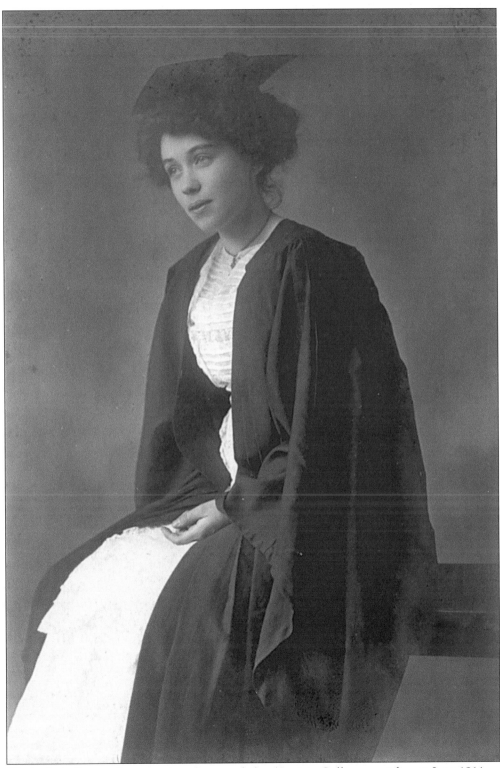

Elizabeth A. Rummel's graduation photograph from Juniata College was taken in June 1911.

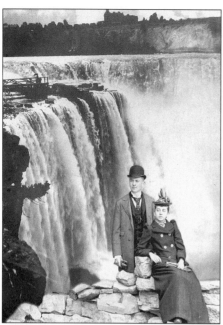

Juniata alumni remember their alma mater from afar. Mr. and Mrs. Frank B. Keller were married on September 15, 1892, and had this photograph taken on their honeymoon trip to Niagara Falls.

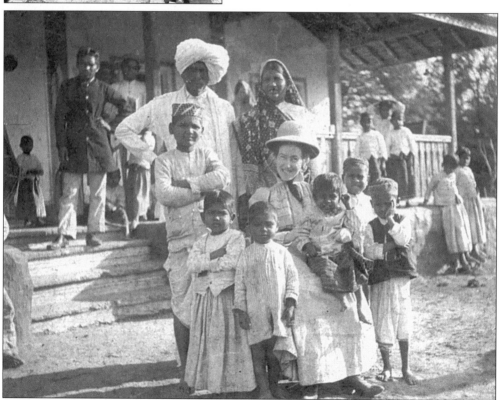

Mrs. D.M. Wertz took a missionary visit to an orphanage in India; she was photographed February 11, 1899. By 1900, the alumni association, which was formed in 1885, included within its records 53 teachers, 7 physicians, 3 attorneys, 10 ministers, a missionary to India, and 15 homemakers.

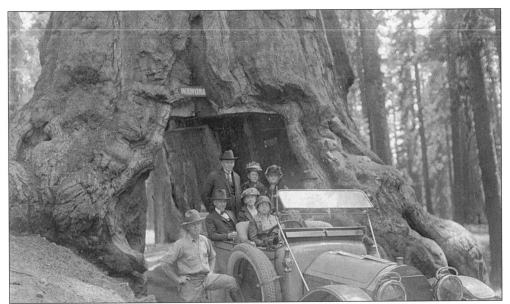

Juniata alumni gather in Yosemite National Park, June 14, 1920. "This picture was taken after passing through the tree, in a Packard machine used for touring through the park by Raymond & Whitcomb touring Co.," wrote the sender of this postcard.

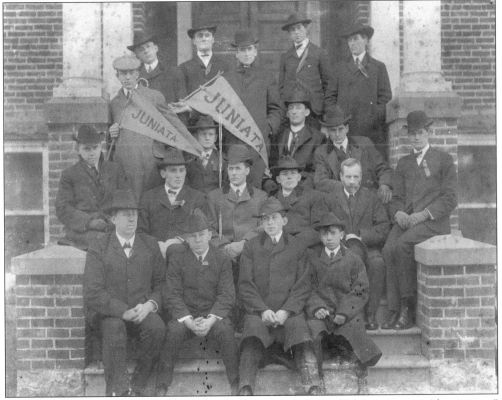

"Must all the ties of four years be sundered? Must we say farewell? Must you go? Alas, it is so." (Last Baccalaureate sermon by President M.G. Brumbaugh, 1929.)

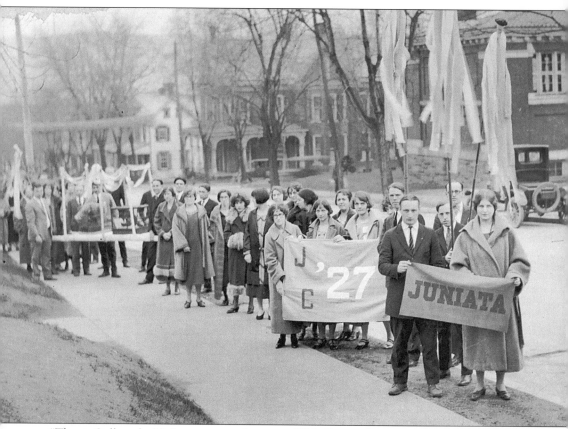

"That is College for Me" was sung to the tune of "My Bonnie Lies Over the Sea," as follows: "So deep in the sheltering mountains; There nestles our College so dear; But far in the great world of service; The fame of her students you'll hear. J.C.! J.C.! That is the College for me, for me; J.C.! J.C.! Yes, that is the College for me!" (Jubilee Edition, *Songs of Juniata*, 1926.) Members of the class of 1927 celebrate Alumni weekend.

Eight

OUT AND ABOUT IN HUNTINGDON

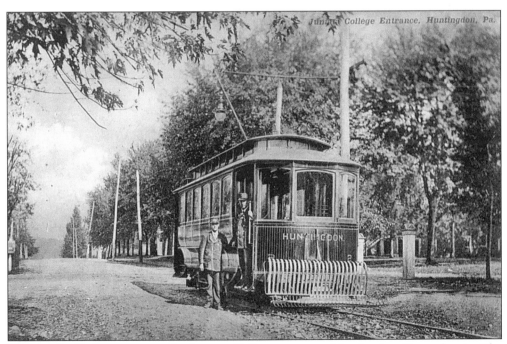

Toonerville Trolley pauses at the Juniata College entrance, Huntingdon, Pennsylvania. The trolley ran every 20 minutes from the train station to the college.

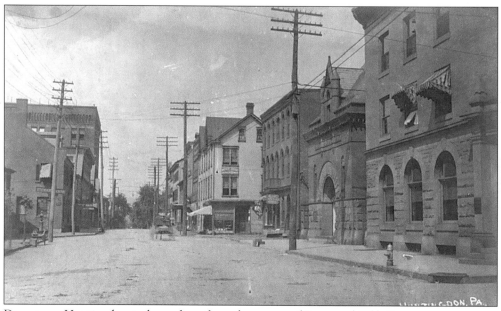

Downtown Huntingdon is shown here from the corner of Penn and Fifth Streets.

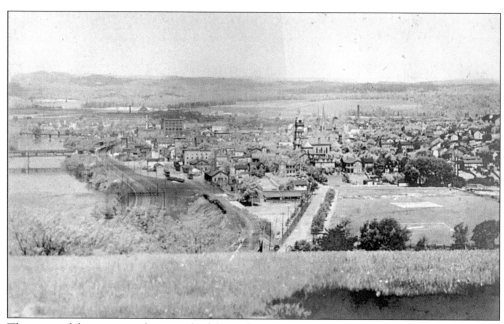

This view of the city was photographed from above.

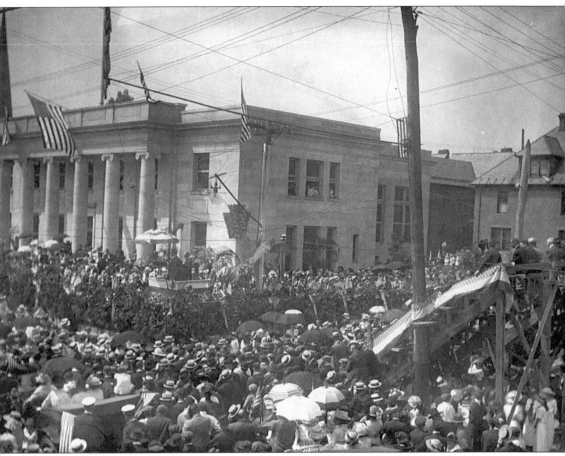

"June 17, 1915, was a big day for the town as well as the college. It was marked by the dedication of Huntingdon's magnificent new post office building . . . The dedication ceremonies began as soon as the new building at Fourth and Washington streets was reached. The crowd was enormous, despite the intense heat. Huntingdon had taken a holiday and every street and building was gaily decorated." (*Juniata Echo*, July 1915.)

This piece came from the second Standing Stone. "The original 'Standing Stone,' fourteen feet high and six inches square, bearing the records of their tribe, was carried off by the Oneida Indians when they left the valley. Another similar stone was set up in the same spot." (D. Emmert, 1901.)

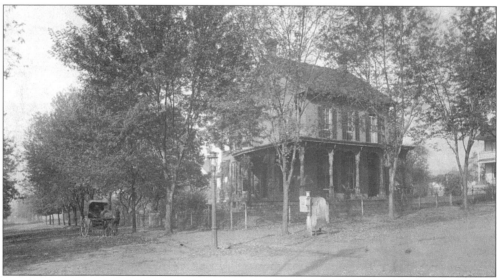

The Jacob H. Brumbaugh house can be seen in the photograph above.

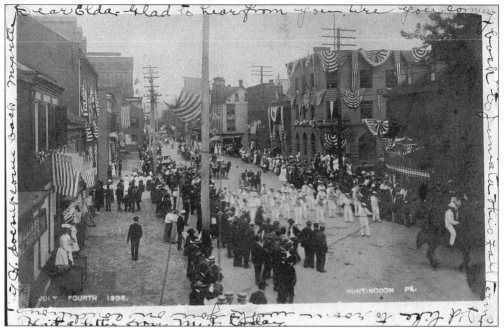

"Dear Elda, Glad to hear from you. Are you coming back to Juniata this fall term? I'd like to room with you on conditions . . ." This postcard depicts the July 4, 1908 celebrations in Huntingdon, Pennsylvania.

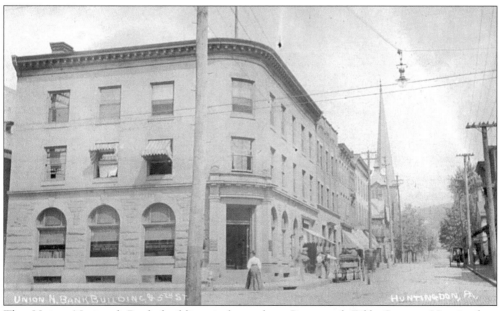

The Union National Bank building is located at Penn and Fifth Streets, Huntingdon, Pennsylvania.

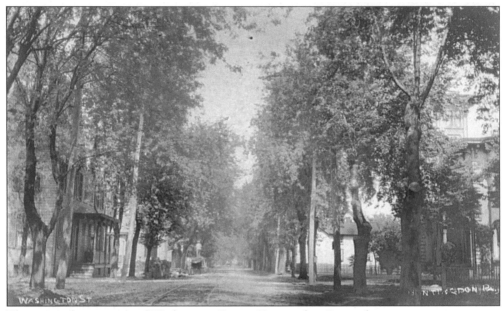

This image shows a view of Washington Street, Huntingdon, Pennsylvania.

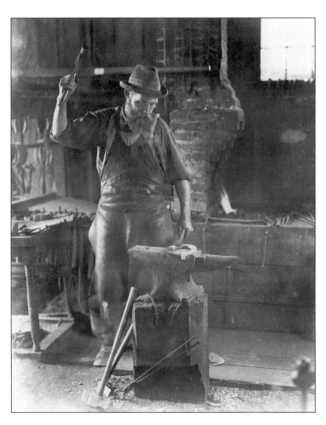

A local smith works in his forge.

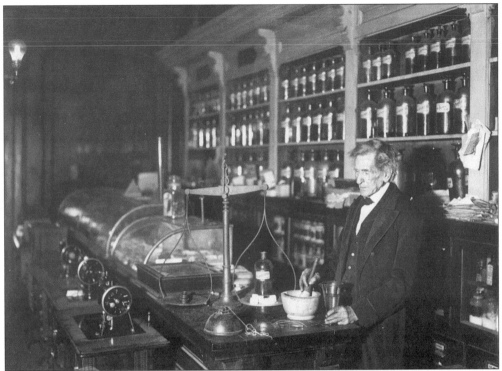

Druggist Samuel S. Smith works in his shop on Penn Street between Fifth and Sixth Streets. This photograph was taken by local photographer Louis Emmert, son of David Emmert, who was renowned for capturing the people and places of Huntingdon County.

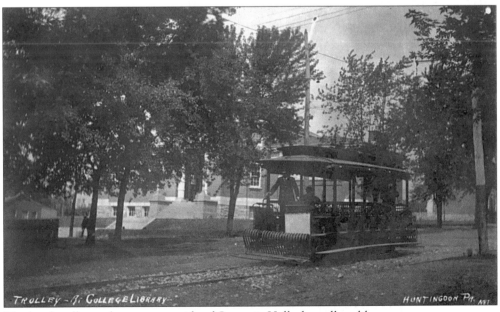

The local trolley makes a stop outside of Carnegie Hall, the college library.

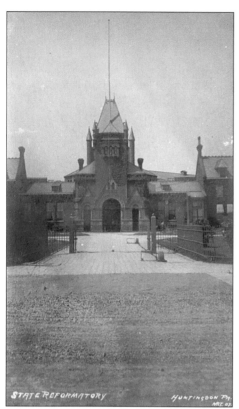

"On the river's high bank is the State Reformatory, with its strong walls and queer guard towers. Its beautifully kept grounds and trim and well-cultivated farm are attractive features in the landscape." (D. Emmert, 1901.) This postcard shows the State Reformatory.

STATE REFORMATORY HUNTINGDON PA.
 NAT. 07.

This view from the cliffs overlooks the railroad tracks.

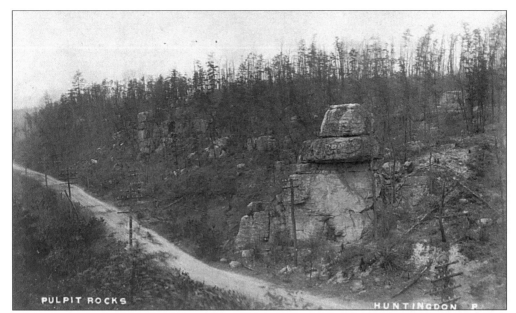

Pulpit Rocks can be found between Bald Eagle Valley and Huntingdon, Pennsylvania.

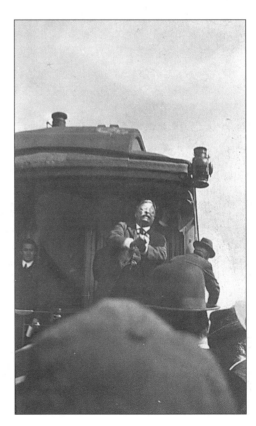

Greeting the crowds was part of Theodore Roosevelt's "whistle stop" campaign through central Pennsylvania, c. 1912. Woodrow Wilson won the presidential election.

This Book is Dedicated to Harold Bennett Brumbaugh, Class of 1933.

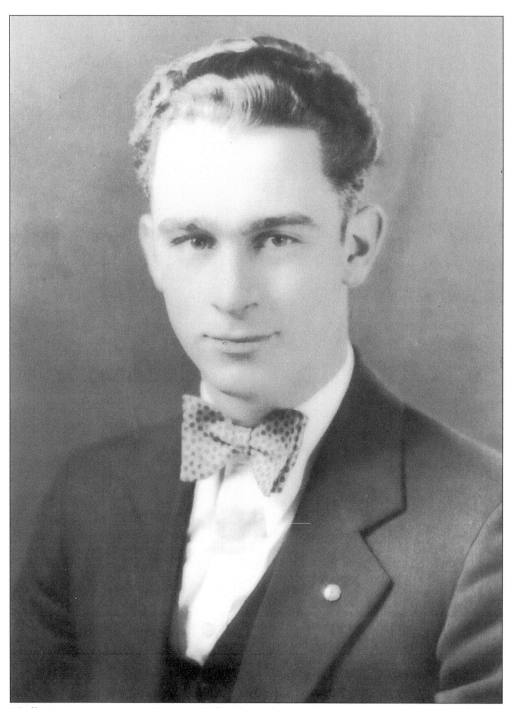

"College opens museum in Carnegie Hall to house historic items, mementos; Curator welcomes relics of campus life." (*Juniata College Bulletin*, Spring 1965.)